Healthy by *Design*

SPIRIT-FILLED & SUGAR-FREE

30-day sugar detox devotional and weight loss plan

Cathy Morenzie

Guiding Light Publishing

Published: August 2022
ISBN: 9781990078170 (print)
9781990078187 (digital)

Published by Guiding Light Publishing
46 Bell St, Barrie, ON, Canada, L4N 0H9

Note: The information in this book is for educational purposes only and is not recommended as a means of diagnosing or treating illness. All situations concerning physical or mental health should be supervised by a health professional knowledgeable in treating that particular condition. Neither the author nor anyone affiliated with Healthy by Design dispenses medical advice, nor do they prescribe any remedies or assume any responsibility for anyone who chooses to treat themselves.

Cover and author photos by martinbrownphotography.com
Cover and interior design by Davor Dramikanin

What If **Losing Weight** Could Become A Meaningful Act Of Worship?

Join my
21-Day Weight Loss,
God's Way Challenge

Includes weekly live coaching
from author and speaker
Cathy Morenzie

21 daily devotions, funny videos,
and powerful insights.

Go From
"Overweight and Overwhelmed"
to "Inspired and Free"

Only $21 for 21 Days
Start Immediately

wlgwchallenge.com

What people are saying about *Spirit-Filled and Sugar-Free*:

"Cathy Morenize has done it again! Like her other books, she has a gift of combining faith and health principles in a way that makes it simple and doable.

Her new book, *Spirit-Filled and Sugar-Free* will motivate you to improve your health while expanding your faith.

Cathy Morenzie has created a must-read devotional which will help you rely on God's power to make difficult lifestyle changes. If you struggle with improving your lifestyle you need to read *Spirit-Filled and Sugar-Free*."

–Susan Neal RN, MBA, MHS

Author of the #1 Amazon bestseller *7 Steps to Get Off Sugar and Carbohydrates*

SusanUNeal.com

"Cathy Morenzie has created a phenomenal daily devotional for you to overcome your problems with sugar. So why wait when you can start your sugar-free daily walk now?"

–Shun Foreman, RN, Certified/Licensed in Holistic Medicine Addiction

Founder of Sugar Mode Off

"I've known Cathy for many years, and can testify to her passion for the Lord as well as her desire for helping people live their best life.

She has a gift of combining faith and health principles, along with motivation and encouragement, in a way that makes it simple and doable for anyone.

Her new book, *Spirit-Filled and Sugar-Free*, will definitely inspire you to make the changes you need.

Cathy Morenzie has created a must-read devotional.

If you struggle with food, sugar, or feel physically or spiritually empty, you need to read *Spirit-Filled and Sugar-Free* so that you can take care of the body God gave you — mind, body, soul, spirit.

I highly recommend this book to help you on your journey!"

–Robbie Raugh, RN – Host of The Raw Truth on WDCX Radio.

Health and Fitness Expert on WKBW TV – AM Buffalo

Author of *The Raw Truth – 7 Truths to Health and Fitness*

Robbieraugh.com

"Prior to starting the [Spirit-Filled and Sugar-Free] detox, my weight loss journey was inconsistent and I started over every Monday. My eating was out of control and I was 222 lbs. This program has transformed my mind, body, and Spirit. I looked forward to my daily reading which was a time of worship, enlightenment, and positive feedback. I have lost 10 lbs. and have 50 more pounds to go. Cathy, you are an inspiration." – **Thesla A.**

"This has been one of the best spiritual and physical (weight loss) programs I've ever taken! I feel renewed spiritually and mentally. I have released weight and feel very healthy. Detoxing from sugar and toxic thoughts is the best gift you could give yourself. I will go through this devotional again because it is so beneficial." – **Ena G.**

"I am so thankful for this devotional. It has helped me learn how to capture those toxic thoughts that have caused havoc in my daily life. These 30 days have not been perfect by any means, but I have grown in my spiritual walk remembering that progress, not perfection is to be my goal. I have released 16 pounds and definitely I am thankful for that. I have gained so much more in spiritual growth and desire to continue that growth in the days ahead as I keep on keeping on." – **Norma U.**

"This devotional was an immense help to me to encourage my focus on establishing a new lifestyle of thinking, planning, and eating because it touches on all of our being: spirit, soul, and body. The daily practice of recognizing toxic thoughts, capturing them, and replacing them with God's truth is truly the only way to transformed thinking and living in total freedom according to God's principles and plan. Thank you, Cathy, for being an instrument of bringing victory and freedom to the struggling captives." – **Beverley R.**

"This devotional challenged me to do better, not only in my weight release journey but also in becoming a better me and finding a better connection with my Daddy God. I found that I had

much more discipline than I thought. I believe that I will do this challenge again to solidify staying away from sugar in my daily life. Thank you so much, Cathy, for putting this devotional together and helping us through this journey." – **Leslie A.**

"This was another wonderful devotional. I thank you for sharing the wisdom that God has given you. I'm grateful to have an opportunity to learn strategies that will allow me to keep my focus on Him, not the food or the scale. Continue making a difference in women's lives." – **Beth H.B.**

"So this was definitely a challenge! But as one who was extremely skeptical about how difficult it would be to follow, after the first week my husband and I hit a groove and meal prepped and were well on our way. I lost 8.2 lbs. and had previously been stuck and couldn't lose more. So this was a major boost in encouragement with weight release. It did also give me pause to realize how much sugar we consume, especially artificial sugar through our drinks. It taught me how to steer clear of it and I do believe it did change my taste buds somewhat. I would definitely say it was worth it, and was tough at times, but overall if you commit you will learn so much about yourself and feel feelings you might never have before and realize you don't need sugar to cope [with]. God will meet you." – **Valorie M.**

"I am so grateful for this challenge and devotional. It taught me a lot about myself, my mindset, my attitude, and my daily habits. This journey has been about so much more than food. It's been an eye-opener to the emotions I have held deep inside, in which I have tried to mask out the food. I am so thankful this challenge allowed me to expose the deep secrets of my heart which led me to make better and healthier choices. Thank you, Lord, for helping me discover. "And I am sure of this, that He who began a good work in me will bring it to completion at the day of Jesus Christ." Philippians 1:6." – **Priscilla M.**

Motivate and Inspire Others.

Share this book!

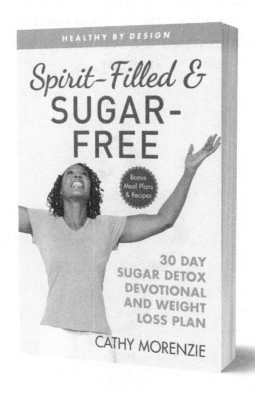

0-10 copies - $14.99
10-50 copies - $13.99
50-100 copies - $12.99
100+ copies - $11.99
(plus S&H)

To order in bulk contact:
support@cathymorenzie.com

The ideal professional speaker for your next event.

Any church or organization that wants to promote a healthy lifestyle needs to hire Cathy Morenzie for a seminar or workshop training.

To book for live or virtual engagements:
cathymorenzie.com/speaking

THE IDEAL WEIGHT RELEASING COACH FOR YOU!

If you're ready to overcome challenges, achieve major breakthroughs, and do it 'God's Way', then you'll love having Cathy Morenzie as your coach.

cathymorenzie.com/coach

Table of Contents

A Message to You!

I get it—that strange, relentless feeling in your body that is difficult to pinpoint. It feels like a bit of anxiety, mixed with anticipation, mixed with yearning.

It can show up after a meal, when a certain emotion hits, or just out of the blue—it's sugar cravings and they've interrupted most of you at some point in your lives, but especially in your weight-releasing journey. Its pull is relentless and can leave even the most strong-willed person feeling powerless. However, once you can tune in to your body and identify its root, you will be well on your way to ending this nasty diet saboteur forever.

Personally, I've had an unhealthy relationship with sugar for most of my life and that's why it's so important for me to share this program with you. Sugar ruled my life for as long as I can remember. In fact, as a child, my mom recalls that I used to talk in my sleep and most of my conversations were about ice cream, cookies, and cakes!

As I grew up, sugar continued to control so much of my life. It probably also influenced my decision to study physical education but not for the reason you might think. You see, physical education studies also included practicums which essentially was 'gym class.' My reasoning was that I could go to school and get credit for burning off all of the excess calories I consumed. Win/win, or so I told myself.

At university I also taught fitness classes. Although I enjoyed teaching, one of my incentives for teaching was to minimize and counteract all the sugar I consumed on a regular basis. I lived on a steady diet of Nerds, Oreos, and a Tootsie roll/caramel combo. I would literally eat them until I made myself sick!

As I graduated and became a personal trainer, my sugar addiction blossomed and became my secret shame. I remember consulting with clients on the telephone while binging on chocolate bars and cakes while I counseled them on the benefits of eating healthy. Talk about hypocrisy! I lived like this for many years, counseling my clients on how to eat healthy, but never able to practice it for myself.

I have a vivid memory of passing out under a table after ending our bible-study group Lenten fast with a feast. I ate so much cake and sweets that day that I went into sugar shock and passed out. Okay, I'm not sure if that's really a thing but I felt awful for days after that episode.

Then a few years ago, after getting sick and tired of suffering in silence, I felt led to write an online course and invite women to take this sugar-free journey with me.

Together, we followed the Sugar Detox Meal Plan by Brooke Alpert. I did okay for the first few days, I cut out some sugar foods, but mostly just found creative ways to cheat by turning to 'sugar-free' sweets.

The second year we offered the detox again, and this time I focused on studying God's Word in addition to following the meal plan. This time was much better, but before long I reverted to my old habits. But all was not lost. I continued to offer my struggles to God long after the challenge was over.

The third time around, I did not try to hide from Him when I gave in to temptations and cravings. The next time I participated I made God my focus instead of worrying about what I could and could not eat, and it made all the difference. It did not happen overnight, but by the grace of God it happened and it can happen for you, too.

Maybe like me, you've always had a love for sugary foods, or maybe it's foods like potato chips or pasta. Maybe you just need something sweet after each meal or maybe your sugar addiction is in the form of juices, sweet teas, or sodas. Whatever form of sugar you're currently wrestling with, at the end of the day too much of it is not good for you. But you probably already know that, and that's what's brought you here.

Know these three things...

1. You're not alone. The average American adult consumes an average of 60 pounds of added sugar a year. [1]

2. It's not entirely your fault. Sugar is one of the most addictive ingredients in the average modern diet.[2] Breaking free from this stronghold will require steps that most people don't understand.

3. God wants, can, and will satisfy your every craving (Psalm 107:9 NIV).

That's why this program is so important for you. *Spirit-Filled and Sugar-Free* (SF&SF) will give you the kick-start you need to help you regain control of your health. Whether it's a full-fledged sugar addiction or you just love sweets, SF&SF will give you all the tools you need to help you kick the sugar habit.

Spirit-filled and Sugar-Free is a 3-in-1 system that will teach you how to detox your body from sugar and your mind from its toxic thoughts that keep you running to sugar, while nourishing your spirit with the Word of God.

1 https://www.heart.org/en/healthy-living/healthy-eating/
eat-smart/sugar/how-much-sugar-is-too-much

2 https://www.frontiersin.org/articles/10.3389/
fpsyt.2018.00545/full

That's why this program will change your life. It incorporates your tripartite being—meaning it is built on the principle that your spirit, soul (made up of your mind will and emotions), and body are interconnected. It's impossible to deal with just one aspect of your being. You can't change your unhealthy behaviors such as over-consumption of sugar until you renew your mind. And you can't renew your mind until you learn how to realign and tune in to your spirit.

Unfortunately, sugar adversely impacts all three parts of your tripartite being.

1. Excess sugar wreaks havoc on your physical health by contributing to a laundry list of illnesses.

2. Sugar breaks the communication between your soul and body by hijacking your brain, so it feel impossible to stop eating sweets, while also destroying your desire to eat real food.

3. It also messes with your spiritual health because, whether you're willing to admit it or not, you've often chosen sweets over God.

That's why I will walk you through the detox, guiding you and coaching you on how to properly nourish your body, soul, and spirit. I will not be coaching you as someone who has mastered this, but as someone who is right in the trenches with you, continually growing in grace each day as I continually submit my sugar addiction to God.

In this book you will discover:

• The addictive properties of sugar

• How a spirit, soul, and body approach can help you to kick your sugar habit

- What foods to eat to keep you from craving sugar
- How to renew your mind when you're craving sweets
- How to prepare and eat healthy, balanced meals
- How to trust God to help you eliminate excess sugar from your life

To help you on your journey, I've also put together some additional free resources for you:

- 10 Reasons Why You Crave Sugar Report
- Hidden Sugars in Foods
- Active Practice Tracker/Checklist
- Active Practice examples, prayers and declarations
- Your 3-Day Kickstart Meal Plan and Recipes

Visit: **spiritfilledandsugarfreebonus.com** to access and download these resources.

Pray this prayer as you begin your journey:

"Dear Lord, I confess to trying hard to find something that will fill the void, and sugar often hits the spot. I crave it and seek it out, but no more, Lord. I'm here to lay it at Your feet. Knowledge is power, and now that I know better I will commit to doing better. Sugar only provides a temporary fix and works as a band-aid, giving me short-lived relief and tricking me into thinking that all I need is 'a little more' to feel better. But in all my efforts, all I've ultimately found is frustration, pain, and more problems. Lord, I confess that I've bought into the lies that say I need some external thing to complete me, although I know You. I confess that I have fallen short of letting You be

the Lord over my health. On this day, I invite Your Holy Spirit to take over and give me a spirit of self-control. I look forward to breaking this sugar addiction once and for all. In Your Holy Name, I pray. Amen."

How The Book is Laid Out

The book contains three sections:

Section 1. Getting Started

This section will answer your most frequently asked questions about this unique approach. It will also give you some background information on sugar and its effects.

Section 2. Spirit and Soul Food

In this section, you will renew your mind with daily devotionals plus revive your soul with daily prayers and reflection questions to help you realign your spirit with God's. It also contains a section to help you reflect on the current day and plan for the next. Each day contains:

SCRIPTURE REFLECTION: Study the daily verse and listen for how the Holy Spirit is leading you.

DEVOTION: Read the daily devotion and see how it relates to your life and health journey.

REFLECT: A time to reflect and record your responses to daily questions. They are simply a guideline to help you direct your thoughts.

PRAYER: End your time with a selected prayer designed to usher you into God's presence.

WHAT TO DO TODAY/TOMORROW

Where appropriate, each day of the program will contain a section that will help you to plan your day or prepare for the following day. It will contain a few questions to ponder and reflect on.

ADDITIONAL SCRIPTURES

Want more of God's Word? Study the additional scriptures to help you dig into God's truths, which He reveals bountifully as you spend time in His Word.

Section 3. The Sugar-Detox Plan

This section will provide you with 2 eating guides.

1. A 3-day kickstart eating guide which consists of three days of consuming less than 50 grams of carbohydrates.

2. A 21-day sugar eating guide referred to as your Spirit-filled Eating Guide. It which will allow you to create your personalized plan. Your daily carbohydrate intake will be approximately 100 grams of net carbohydrates.

We're also excited to bless you will a special bonus. Take all the guess-work out of what you should eat and download our sample 3-day Menu with accompanying recipes, tailor-made for you by our nutritionist. Claim it now at at spiritfilledandsugarfreebonus.com

Section 1. Getting Started

Frequently Asked Questions

What is it?

The Spirit-Filled and Sugar-Free Challenge/Devotional is three programs in one! It's a step-by step guide to show you how to:

1. **Body - Eliminate excess sugar from your diet** by following a low carbohydrate eating guide that will balance your hormones, mood, energy levels, and blood sugar while strengthening your immune system. It includes a 3-day kick-start eating guide followed by a 21-Day Spirit-Filled Meal Eating Guide to help you maintain your boundaries at approximately 100 grams of net carbohydrates per day.

2. **Soul - Renewing your mind** with the Word of God is the best way to replace toxic thoughts that often lead you to eat sugar to soothe you. Our 3-Step Reset Process© will help you to capture your thoughts and renew them with the Word of God.

3. **Spirit - Draw you closer to God** and rely on Him to strengthen your will instead of trying to overcome sugar in your own strength. If you trust in God, then it only makes sense that you would invite Him into this area of your life. After all, if you're anything like me you've probably been trying it your way with limited success, right?

This spirit, soul, and body approach will guide you through 30 days of inspiring devotionals and a sugar detox plan, plus provide you with a 3-Step Reset© Process to rewire your brain so that you can forever change your unhealthy relationship with sugar.

Why is this program different?

If you're tired of feeling like you're at the beck-and-call of your sugar cravings, then you're in the right place. If you can't seem to kick the sugar habit no matter how many times you've tried, then get ready for a new approach to sugar detoxing — one that incorporates spirit, soul, and body!

The SF&SF (Spirit-filled and Sugar Free) Detox will help you to reset your body by eliminating processed foods and excess sugar from your diet so you can reset your taste buds, improve your health, and strengthen your faith.

SF&SF understands that simply focusing on fixing behaviors is futile. Until you understand why you do what you do and give those underlying cravings to God, you'll continue to repeat it. Until you can fully grasp what emotions are driving you to consume sugar, you'll forever default to focus on band-aid solutions without ever fully healing the root.

Yes, it's one thing to know in your head that the answer is Jesus. If you went to church in your childhood that was drilled into you, but if you're anything like me you never learned how to apply that truth to your everyday life — like breaking sugar addictions.

Why is sugar so bad for you?

Excess sugar is the main cause of obesity, as well as a host of other diseases such as diabetes, heart disease, cancer, and depression just to name a few.

When you eat sugar the body's natural response is to release a hormone called insulin, which regulates the amount of sugar that enters your bloodstream. Sugar is highly addictive, and

studies have shown that it has a similar effect on the brain as cocaine and other addictive drugs.[3]

There are dozens and dozens of sources of sugar. Some of these sugars– especially the ones containing high fructose corn syrup suppress important hormones such as leptin. Leptin's role is to tell you that you're full. This is why you can keep eating and eating sugary foods and never feel satisfied. High fructose corn syrup is found in a lot of the processed foods you eat.

An important principle to remember about food and your health is that God designed you to be in good health naturally! This means that we're not wired to eat processed, unhealthy foods, but real, whole foods. Cravings, especially sugar cravings, are your body's response to something that has upset the natural balance of your body's biochemistry. Like a check-engine light in your car, cravings are alerting you that something needs attention. In most cases cravings are not hunger, and therefore we should not treat them as such. They are your body's way of telling you that something is out of whack. When you can understand this principle, my hope is that you will adopt a curious and inquisitive approach to satisfying your cravings by understanding what needs attention. Imagine how great it would feel eat when you're truly hungry instead of giving in to every craving you experience.

What to eat on the Sugar Detox Meal Plan

The sugar detox is composed of two phases.

1. The 3-day kickstart consisting of consuming less than 50 grams of net carbohydrates. This will allow your body to get accustomed to living without sugar sooner rather than later. It lasts for only three days, which makes it easy for almost anyone to adhere to. After all, we can all go without sugar for three

3 https://www.ncbi.nlm.nih.gov/pmc/articles/PMC2235907/

days, right? It involves the elimination of all grains, processed foods, dairy products, sweeteners, alcohol, and some fruits from your diet.

2. The kickstart is immediately followed by a 21-day, Spirit-Filled Eating Guide which will consist of 100 grams of carbohydrates per day for 21-days.

You can track your carbohydrate consumption using an app such as MyFitnessPal (myfitnesspal.com) or Lose It! (loseit. com), but it is not mandatory for your success.

If you don't want to be bothered with tracking carbs, you can also upgrade to a done-for-you, 21-day Spirit-filled Meal Plan complete with shopping lists and recipes. Go to spirtfilledandsugarfree.com for more information.

What does it mean to detox?

As I refer to the term 'sugar-detox' in this book, I define it as a verb, "*to abstain from or rid the body of toxic or unhealthy substances.*" The emphasis is on halting the unhealthy habit of consuming excess sugar. The focus will not be on detoxification (think of special tonics and pills that make you go to the bathroom) of the body. However, I suspect that once you stop consuming excess sugar, your body's natural detoxification system will be enhanced.

I also refer to detoxifying your mind, which refers to paying attention to unhealthy thoughts and renewing your mind with the Word of God. Understand that you'll never be able to stop toxic thoughts from entering your mind, but you will become skilled at thinking thoughts that are true, honest, just, pure, lovely, of good report, and of virtue (Phil 4:8 paraphrase). These thoughts will essentially crowd out and overpower the toxic thoughts. That's why God's Word says to be filled with the Spirit (Eph. 5:18).

What can I expect overall?

To break free from sugar dependence, to start to feel clear-headed, have more energy, release weight, and strengthen your relationship with God.

How long does it last?

The entire Sugar Detox lasts for thirty days which includes four prep days, three detox kickstart days, twenty-one day detox, and three wrap-up days.

What can I expect at the beginning of the program?

Due to decreasing your sugar consumption, you may experience fatigue, fogginess, headaches and intense cravings, and feel hungrier. However, this will pass and you will begin to feel better. If possible, try to rest as much as you can, and take naps if needed. Drink lots of water and take things gently. Withdrawal symptoms usually subside after the first few days.

How can I best prepare?

Plan your meals and snacks in advance. Many people struggle with snacking. Here are some examples of snacks that you may include:

- Kale chips (roasted kale in the oven)
- Cut up vegetables with hummus or tofu dip
- Celery and nut butter
- Cucumber boats with tuna
- Nuts
- Protein smoothies
- Dark chocolate
- Low-carb fruits (berries)

Can/should I exercise during the detox?

You may find that you just need to rest initially, but movement will obviously be beneficial. So choose a gentle form of exercise like a short walk and gradually increase as your body grows accustomed to your new diet.

Do I count carbohydrates or sugar?

For this detox, you will be paying attention to carbohydrate grams which will automatically include sugar. This will include both complex (potatoes, rice, pasta, fruits and veggies) and simple carbohydrates (candy, fruit juice).

Does the detox count net carbohydrates or total carbohydrates, and what's the difference?

You will be paying attention to net carbohydrates. The difference is that 'total' carbohydrates refers to carbs from all sources. This usually includes sugar, fiber, and sometimes sugar alcohols. 'Net' carbs refers to everything included in the 'total' number minus the fiber. This is because fiber is not absorbed into the body because it passes through the body undigested, so it will not impact your blood sugar like other carbohydrates. Put simply, net carbs = total carbs – fiber.

What's the difference between added and natural sugars?

There are very important differences between added sugars and sugars that occur naturally in foods like fruits and vegetables.

The biggest difference is that natural sugars also contain fiber and various micronutrients which support your health, while added sugars are those found in processed foods such as candy, soft drinks and baked products, or any sugars that are not naturally occurring in the food you're consuming. Instead of contributing to your health, added sugars rob your body of

important nutrients that are essential to your health and should therefore be minimized. Once you've completed your detox, test out foods that contain natural sugars and find ways to incorporate small amounts of them into your healthy lifestyle.

Is the sugar detox hard to do?

The eating guides make planning easy, and you can make healthy foods you like and adapt your current recipes.

In terms of how you will feel, the first full week is the hardest, as your body is adjusting to life with less sugar. It may feel limiting at first, because you have such a simple selection of foods to choose from, but as you reintroduce certain foods and begin to get into a routine of thinking ahead, planning and preparing within the boundaries, it becomes easier.

The detox does not necessarily focus on a calorie limit, so while you can note your calorie intake, and obviously don't want to overeat, the focus is on low-sugar foods rather than on calories. You will begin to release weight simply because of the healthier foods you will be eating. As you begin to feel better, think more clearly, and gain more energy, the motivation to keep going increases.

Why does detoxing feels so bad?

Despite the evidence suggesting how lethal sugar is, the health community is pretty divided on whether sugar addiction is a real thing because it seems a stretch to compare sugar to cocaine, but if you're addicted to sugar then you know the power it has over you.

The fact remains that sugar triggers the release of dopamine in the same area of the brain implicated in response to heroin and cocaine.[4]

4 https://www.ncbi.nlm.nih.gov/pmc/articles/PMC2235907/

Eating excessive amounts of sugar literally changes your brain[5] so that it becomes tolerant of the sugar, causing you to require more to get the same 'happy feelings.' All of this leads to a vicious cycle of cravings and needing more sugar to feel good. That's why when you begin to cut out the sugar from your diet in the coming days, your cravings will get more intense and you may experience withdrawal symptoms — at least, at first.

What withdrawal symptoms should I expect?

It's because of sugar's highly addictive properties that you'll want to prepare yourself and minimize any unpleasant side effects.

How your body reacts to withdrawing from sugar will vary from person to person. It depends on how much sugar you are currently consuming, but there are many things that you can do to begin to decrease the negative effects. Symptoms can last from a couple of days to a couple of weeks, but will eventually pass.

Withdrawal symptoms can include the following:

- Low mood/energy/fatigue
- Depression
- Anxiety/Nervousness/Irritability
- Changes in sleep patterns — difficulty sleeping or sleeping too much
- Difficulty concentrating or focusing/forgetfulness
- Sugar or salt cravings
- Light-headedness and dizziness
- Nausea

5 https://hms.harvard.edu/news-events/publications-archive/brain/sugar-brain

Here's what you can do to decrease your withdrawal symptoms:

1. Increase your fiber content to help stabilize your blood sugar levels and help you to feel full.

2. Drink more water and herbal teas to help you stay hydrated and improve your overall mood. Water will help balance your blood sugar, keep your system running effectively, and help with constipation that may accompany the detox.

3. Participate in some moderate exercise to help keep your energy levels up and boost your mood.

4. Increase your protein and fiber consumption to help you feel full and satisfied.[6]

5. Get a good night's sleep to help manage your stress levels, energy levels, and your mood.

6. Try lemon water or something bitter[7] which is said to shut down the parts of the brain that makes you want sweets.

Why the 3-Day Kick Start?

Although a gradual approach to eliminating sugar will help to decrease the intensity of any withdrawal symptoms you may experience, it also means that you will experience the symptoms for longer, so the purpose of the kick start is to allow your body to get accustomed to living without sugar sooner rather than later. It's analogous to just ripping off the band-aid quickly instead of prolonging the inevitable.

6 https://pubmed.ncbi.nlm.nih.gov/29955731/#:~:text=Conclusions%3A%20Compared%20with%20LP%2FLFb,weight%20reduction%20and%2For%20maintenance.

7 Lvovskaya S, Smith DP. A spoonful of bitter helps the sugar response go down. *Neuron.* 2013;79(4):612-614. doi:10.1016/j.neuron.2013.07.038

Will it take much preparation?

If you are used to making your own food it does not take any more preparation than usual, but you do have to think ahead, make a meal plan, and buy what you will need. Making a meal plan for a week can feel overwhelming if you're not in the habit of planning ahead, so it could be broken down into three days, then four days, or even just planning the day before if you have the ingredients or are close to the store.

How can I best prepare and be successful?

The first and most important thing to do is to sit down with the Lord and pray about it, seeking what He wants you to do, and what foods He wants you to eat. Commit it to Him, asking Him to guide you and give you wisdom and help as you plan and prepare.

Secondly, make a meal plan and then a shopping list — whether it is for a day, a few days, or a whole week. Then set aside time to go shopping and prepare certain things ahead of time. (If you have not had time to prepare any food ahead of time that's okay, too — it doesn't always work out perfectly!)

Third, listen to your body and eat when you are hungry so that you will not be in a position where you suddenly get too hungry and want to grab something quick and therefore eat mindlessly.

Does it work?

Absolutely! The plan has many benefits, and if you have been used to eating sugar and have had a high carbohydrate intake there will be a noticeable difference in how your body and mind feel. It is likely that you will release a little (or a lot of) weight, too. The detox will help you to become much more aware of what is in the foods you eat and help you to make better food

choices. The program also helps you to foster discipline and to learn to lean on the Lord for your strength and self-control.

(If you have an addiction to sugar rather than just a simple love for sugar, you will find that it breaks the binging cycle and makes you feel in control of your food choices rather than it having control over you! You will notice an increase in energy levels, and a clearer head, even as soon as day three of the kickstart.)

What is the hardest part?

Most people who participate in sugar-detox programs like this find the first few days the most challenging. To make this process as simple as possible, plan ahead as best you can and give yourself lots of grace, knowing that adjusting to a new way of eating or preparing foods is always a challenge.

Should I drink lots of water?

The program requires at least 64 oz (2,000ml) water each day (which is eight 8-ounce (250ml) glasses). Ideally, a more accurate measurement is to drink half of your body weight in ounces, so if you weigh 200 pounds you would consume 100 oz of water, which is equivalent to 12.5 cups (100/8)

What foods can I eat?

You will be eating healthy, unprocessed foods with low sugar content. You can check out the and Spirit-Filled Eating Guides in section three of this book.

Is it expensive?

Eating on the sugar-detox plan should be no more expensive than usual, and in fact may be less expensive as you will be cutting out the excess processed foods and drinks you may have been consuming in the past.

Do I have to buy any special foods?

No, but this may be a new way of eating to you, and so you might feel that way!

Do I need to continue to log my food?

No, it is not mandatory, unless you are currently tracking your food, then you should continue. (If using MyFitnessPal you may need to adjust the settings, and in the macro chart will probably notice a difference in balance, as you will be eating fewer carbohydrates, at least initially.)

What if I mess up?

If you do, bring it straight to the Lord and seek His help, asking Him to give you the right mindset. Commit to getting back to the boundaries.

If you have stepped out of the boundaries along the way, simply regroup and keep on going.

Whatever you do, do not beat yourself up or be tempted to say things to yourself such as, "I've blown it! I may as well really blow it!" Or "I've failed again! I might as well give up!" Slip-ups happen, so don't expect to do it perfectly. It's not 'all or nothing', so if a slip occurs, acknowledge it, correct, and continue.

What do I do once I have finished the detox?

Keep on going! Follow the Spirit-filled guides(Section 3) to maintain healthy eating boundaries. Know that this is the beginning of a wonderful journey. You may decide to remain sugar-free or you may choose to add some foods back into your eating plan. The post-detox section will show you how to most effectively reintroduce these. For additional support and

accountability, consider joining my Weight Loss, God's Way coaching program (cathymorenzie.com/coach). Our coaching program will provide you with daily accountability to help you stay focused on all your health goals.

What if I go on vacation?

Follow the Spirit-filled guide (Section 3). Make the best choices from what is available. If you are able to take some snacks that are within the boundaries or can buy them when you get to your destination that will help. If the hotel or restaurants have a website with menu/nutritional information, you could choose ahead of time what you will eat so that you will not be tempted to overstep your boundaries.

How do I handle birthdays or special occasions?

Plan and make the food choices ahead of time if you are the host. Explain to friends and family what you're doing so that they understand and can hopefully support you. Follow the Spirit-filled checklist and eating guide located in section three.

If you find yourself in a situation where you are not in control of the menu, eat something healthy before you go so that you will not eat as much when you are there. If you find you are in a situation where you have to eat something at someone's home that is not on the Spirit-filled food list, and there is nothing else available, just eat in moderation and get back on track for your next meal. (See 'What if I mess up? in the Section 1')

What is the best thing to do when I go out to eat?

If the restaurant has a website with menu/nutritional information, make a choice ahead of time so you will not be tempted once you are there to go out of your boundaries.

If you're in a bind and there are no healthy options available, do the best you can. If the only options are burgers for example, go without the bun and add a salad if possible. Try to sit down and eat it as a proper meal so that you take time to savor each bite rather than eating it fast and mindlessly, leaving you feeling hungry. Or this might even be an opportunity to fast and spend time with the Lord.

What to Expect in the Detox Program

Most people quit programs because of their unfulfilled expectations —this means their expectations do not line up with their results. The getting started instructions will help you get clear on what you should and should not expect. Planning will be one of the keys to your success. Be sure you've reviewed the entire eating guide in section three of this book. You will need to shop and prepare your meals in advance. As you review the eating guide, substitute in some of your favorite foods.

What to Expect

Resistance

Resistance is push-back from yourself that you will feel. It is part of the process of growth and change. Don't be surprised when it comes. Some resistance is God perfecting you, and some are the enemy keeping you from your victory. Discern which is which and pray accordingly. Yes, you may want to quit; yes, the enemy will try to convince you that you can't do it. Know that victory is waiting on the other side. "Consider it pure joy, my brothers and sisters, whenever you face trials of many kinds because you know that the testing of your faith produces perseverance. Let perseverance finish its work so that you may be mature and complete, not lacking anything." James 1:2-4 (NIV)

Work

You will get out of this program exactly what you put into it. If you don't do the work, then you cannot expect to see a change. "Whatever you do, work at it with all your heart, as working for the Lord, not for men, since you know that you will receive

an inheritance from the Lord as a reward. It is the Lord you are serving." Colossians 3:23–25 (NIV)

Renewed joy and hope in the Lord.

Something beautiful begins to happen when you spend more time with the Lord. He will minister to your heart and soul. Expect that your relationship with the Lord will be strengthened as a result of this journey.

Fear

Fear is at the root of most of the things that stop us in life. During this challenge, you will be uprooting fears that may be related to your sugar-free journey. Resist the urge to try to confront too many fears at once. Accept that they exist, perform your 3-Step Reset© and trust that God is more than able to help you move past them.

Possible Hunger

If you are anything like me, hunger can trigger feelings of panic and fear. Although your goal is not to restrict calories, you may experience periods of hunger from time to time. At these times you'll do one of the following:

1. Begin your 3-Step Reset© (next chapter).
2. Notice what is true hunger from habit and respond appropriately.
3. Pay attention to whether you are truly hungry or if you've mistaken your thirst for hunger. Drink lots of water every day and invest in some herbal teas to curb your appetite.

Results based on your individual goals

In a journal, write down your intention for this challenge. Is your goal to complete it no matter what happens, to remain accountable, to be transparent, and to spend time with God every day? Be intentional about what you want to achieve. Take your focus off the scale. See weight loss as a bonus, but not as the main goal.

Changes in your patterns

Are you always doing things at the last minute then wondering why things do not work out for you? Maybe you do not take the time to plan your meals. There will be habits that you notice that will get in the way of your success. Journal them and turn them over to the Lord. You cannot change everything at once, but you should take note of them for future reference.

We focus on practice, not perfection

To all my fellow perfectionists and control-freaks out there, resist the urge to try to do too much, to do it perfectly, obsess on weight loss, or to do it your own way without support and accountability. Trust me, it will not work. Practice taking action steps every day and learn to master the skill of discipline. Commit to doing every day, but if you miss a day, don't sweat it … just jump back on board the following day.

Your success will largely depend on your ability to turn this process over to God and trust Him to help you learn new healthy habits to lose weight.

Be aware … a large percentage of people begin to fall off of most programs around day four or five. Knowing this, you can pray, plan for it, and prepare.

It works if you work it

I'm not going to lie to you and tell you that this will be a breeze. Overcoming sugar dependency will take a lot of prayers, support, discipline, courage, and faith. It can only work for you if you commit to the process. Leave yourself time daily to plan your meals, renew your mind, and pray.

Do your best not to go into the day without a plan. Life will throw curveballs at you even with the best-laid plans, so do your part and get organized. The more you participate in the process, the more you will benefit from it.

Plan and Prepare

Being prepared is a big part of your success. Spend time getting clear on everything you will need to be successful on your journey.

At the end of each lesson, you will take some time and prepare for the following day. Many people struggle with eating the right foods because they are not prepared, and end up eating what's convenient and easy. I suggest you prepare as many meals as possible in advance.

When will you go grocery shopping? Will you wake up a bit earlier to study your prayers? Will you track your food?

The first three days of the detox are dedicated to helping you plan and prepare.

Sugar Detox

The purpose of the sugar detox is to rid your body of excess sugar. The first three days of the kickstart will be the most challenging because your body may experience detox symptoms

such as headaches, fatigue, crankiness, a funny taste in your mouth, or lightheadedness.

Mind Renewal

The purpose of the mind detox is to renew your mind from the unhealthy thoughts that keep you stuck. Every day you will be breaking down a toxic thought and building up a healthy replacement thought. You will be learning how to be present and conscious of the thoughts running through your mind. The initial days of the detox are focused on renewing your mind. Give yourself at least fifteeen minutes on the first few days to do these exercises, as they will form the basis for the entire challenge. Do not worry, I will give you lots of instructions and guidance in the first week of the challenge to help you master this tool.

I suggest you spend time prior to eating your meals to renew your mind. This will serve a few different purposes.

1. It will help you to be conscious of what you're about to eat.

2. It will allow you to be conscious of your thoughts around food.

3. It will remind you to always bring God into this process of healthy eating.

4. It will slow you down and allow you to enjoy your food. Most people eat too fast.

Be sure to have your active practice worksheet (if you have not yet downloaded this complimentary gift be sure to do it now at spiritfilledandsugarfreebonus.com). If you're not able to carry your worksheet with you then track it on your phone and enter it at a later date.

Spiritual Renewal

The daily devotional will ground you in God's promises. Renewing your body and mind is developed as you spend time with God, not in your own strength.

At the start of each day (ideally), study the scripture of the day, read the daily devotional, journal your thoughts, and recite a prayer. Do your best not to rush through this part of the program.

Planning for Tomorrow Section

Each day will contain a section that will help you to prepare for the following day. Ask yourself the following questions before going to bed each night:

1. What time will I need to wake up to complete my daily devotion?
2. Do I have any meetings or anything that will cause me to go off my routine?
3. Will I be meeting with any challenging people who may trigger me?
4. Do I have the necessary foods that I need to be successful?

Pray

I suggest keeping a prayer journal to hear how the Holy Spirit is speaking to you during your prayer time. Don't skip this step. You already know from past experience that you can't do this in your own strength, so keep turning this journey over to Him.

Get Accountability

Accountability and support are foundational to your success. That's why emphasize it in all of my Healthy by Design weight loss devotionals, books and courses. I understand the importance of sisters praying for each other and holding each other accountable. Invite a friend or family member to go through this program with you.

Renewing Your Mind

This section is so key I decided to attribute an entire chapter on it so that I could elaborate more.

What makes this program so unique is my body, soul, spirit approach to changing behaviors. This section is what will make the difference from this being just another sugar-detox you participate in, to the final sugar-detox you will ever need. Understanding this is foundational to both growing in your faith, eliminating bad habits, and even beginning new healthy habits. Since it's so important, I'm going to take my time and go over this in detail. If you're anything like me, you can shut down as soon as something seems too spiritual or difficult to understand, so before reading this section know that you have the mind of Christ and therefore can easily understand this teaching.

> *"So from now on we regard no one from a worldly point of view. Though we once regarded Christ in this way, we do so no longer. Therefore, if anyone is in Christ, the new creation has come. The old has gone, the new is here!"*
> 2 Cor 5:16-17 (NIV)

In Christ, you are a totally new creation. That's why you are not to look at yourself (or others) from a worldly perspective as the scripture says. This vantage point only focuses on your weaknesses, frailties, and imperfections. You know yourself in the natural but you don't know who you are in the spirit. And that's where the problem lies. You are to live out your life in the spiritual realm (Romans 8:6).

If you could truly understand the power you have in the spirit, your life would radically change. The bible says that when you are born again, you become a brand new person.

If you're anything like me, you may have felt confused with this scripture because you may not feel any different. And in fact, you probably still acted the same before and after you accepted the Lord as your savior. You still struggle with your weight and you still crave sugar. Where is the power that scripture talks about to overcome strongholds, you may be wondering (Luke 10:19, Romans 6:10-11).

That's because it's not your physical body that God saved and it's not even your soul. What became new is your spirit. It's your spirit that became separated from God when Adam sinned. It's your spirit that needs to be governed by God's spirit. This is where your power comes from.

You are a spirit, you have a soul, and you live in a body. And it's so important to understand the connection. Look at what the Word of God says:

In Genesis 2:7 (NIV), the bible says: "Then the LORD God formed man (Adam) from the dust of the ground and breathed into his nostrils the breath of life, and the man became a living being." Here we see God creating Adam in His image as a three-part being - spirit, soul and body.

God created man from the "dust from the ground" refers to his body: "breathed into his nostrils the breath of life" refers to man's spirit; and "man became a living being" refers to soul.

According to this scripture, when God's Spirit infused with the physical body, man's soul was created.

Like adding hot water to a tea bag, the two individual items created a new substance called tea.

God desires the perfect blending of these three natures, with the spirit having all the power and the soul being the fulcrum

between the body and spirit. The soul determines whether we lean into the whims of the body or the grace of the spirit.

Put another way, the key to living an effective Christian life is renewing your mind through what God has done in your spirit. Although there is no physical place called your mind. It is part of your soul which I will talk about next.

Let's look at the functions of the three parts of our being:

Spirit

God's desire is for you to dwell exclusively in the spirit, dying to your flesh, your impulses, and sensual desires. Often referred to in the bible as your heart, (2 Cor 5:17, 1 Cor 2:16) it is the ruling power of your being but only when your soul chooses to align with it. It possesses three functions

A. Conscience, which distinguishes between right and wrong.

B. Intuition. Direct sensing independent of outside influences such as your mind or emotions. It's the inner knowing

C. Communion. Our spirit communicates with the Holy Spirit.

It gives us our God-consciousness. When we live according to the spirit (Romans 8:6) our cravings for everything except God dies.

Your spirit is also the part of the heart that is immediately changed the moment you call upon the Name of the Lord.

Soul

Soul represents your individuality and personality. It also consists of your mind, intellect, and emotions. This book will continue to refer your mind. It is the place where your thoughts are formulated and carried out. Your soul, mind and thoughts

can be very abstract terms because we can't see any of them, but we experience their benefits or consequences each day.

Because God loves us so much He gave us a soul so that we would be free to choose freely and willingly to obey Him.

If your soul wills to obey God it will allow the spirit to rule, or it can suppress the spirit and allow your flesh to lead (Romans 8:6).

Your soul stands between your spirit and your body, binding these two together. Your soul works to keep your body in subjection and your spirit governing. It is regenerated each day as you renew your mind (Rom 12:2). Your soul gives you your self-consciousness.

Body

Your physical body is the medium by which you contact the outside world. In his book, The Spiritual Man, author and Christian leader Watchman Nee describes our body as the part of you that gives you your world-consciousness. You experience the world through your five senses.

It's your earthly tent. Your Earth suit. It allows you to live and exercise your God-given dominion on the Earth, and is the vessel through which you carry out your kingdom assignment.

Jesus is our example of how to live align our three-part being. He lived on earth in a physical body with all its temptations, but only did the will of the Father as He lived a spiritual life.

Spirit, Soul, Body and Sugar

When you attempt to change a behavior, such as eliminating sugar from your diet, you often begin with trying to make

yourself stop. But that plan never works, as you can probably attest to.

What works is to change the way you think (Romans 12:2). Your mind (remember is part of your soul) is really at the center of what drives your behaviors — including your desire for sugar. It is the gateway between your body and your spirit, meaning that it interacts and drives your brain and also has the power to choose to yield to your spirit. If you yield your mind to your spirit then you will not give in to your desires, as Romans 8:6 teaches you.

So you see, you've been going about it all wrong. Your body is governed by and therefore obeys your soul, and your soul should be governed by and under the control of your spirit. If you want to change your body and behaviors then you have to focus on aligning your soul with your spirit, because that's where your power comes from.

Although your spirit has the power, your soul has to humble itself to it. Life works when the three parts of your being are in alignment.

There is a total transformation that takes place in every believer that is born again and accepts Jesus as our Lord and Savior. (2 Cor 5:17)

God gave us a new nature; He has totally changed you. If you don't understand the concept of spirit, soul, and body then you won't see that it's your spirit that got totally changed at salvation. It's a done deal. This change takes place in the spirit and has to work its way into the soul and then the body.

That's why it's futile to try to change only your body or your thoughts. That's why you get discouraged and keep quitting.

The spirit of Jesus lives in you so that you are a totally new person. Your responsibility is to get your soul in agreement with spirit by reading God's Word. Your spirit has to flow through your soul (mind, will, and emotions) in order to impact your physical body. When our soul aligns with Spirit the body must follow, overcoming its cravings and whims.

When you look into a mirror, you see your outer reflection. But if you want to see a true reflection of who you really are, you have to look to God's Word. It gives you a perfect picture of who you are in your spirit.

That's why, in addition to following the Spirit-filled Eating Guide, each day you will also practice renewing your mind through a process called the 3-Step Reset©.

It is a powerful spiritual weapon to bring conscious awareness to the thoughts that lead you running to sugar. Renewing your mind through the 3-step Reset© will be critical to healing your unhealthy relationship with sugar.

Here's how sugar impacts your spirit, soul, and body:

1. When your body is full of toxic foods such as sugar, it blocks the signals that go to your brain that tell you when you're full and should stop eating. It also feeds the insatiable harmful bacteria in your gut that keep craving more and more sugar. Think about your stomach like a second brain, driving your sugar cravings and telling you to eat more.

2. Sugar stimulates dopamine, which is a neuro-transmitter made in your body. When you consume excessive amounts it can steer the brain into overdrive and kick-starts a series of unhealthy events such as loss of control, uncontrollable cravings, and the need to keep seeking out more and more sugar. This

makes it feel impossible for the body to submit to or obey your soul (your mind and will).

3. When your mind is full of toxic thoughts, it cannot properly connect with the spirit to receive the wisdom that it needs to tell you to stop eating and remind you of the dangers. A toxic mind destroys your desire for real food and keeps you wanting sugar. The more sugar you consume, the more you crave which shuts down the rational and logical part of your mind and so they cycle continues. Science teaches us that your mind that drives your digestive organs.[8] That's why it's critical to focus on your mind if you want to change your desire for sugar.

The 3-Step Reset

This detox and challenge will teach you how to replace your limiting toxic thoughts with healthy, affirming, positive thoughts. It will involve five to ten minutes of focused, conscious exercises each day to retrain your brain to think differently. However, it'll probably take you a bit longer during the first three days for you to identify what toxic thought you will be working on. Retraining your brain and eliminating toxic thoughts will be done via our 3-Step Reset© Plan. I suggest practicing the first two steps of the reset, first thing in the morning. Then practicing the third step several times throughout the day.

The three steps are:

Step 1. Pause

Step 2. Pray

Step 3. (Active) Practice

8 https://www.ncbi.nlm.nih.gov/books/NBK279994/

Step 1. Pause

Because most of your thoughts are unconscious, logically most of your actions and behaviors will also be unconscious thus impossible to control. However, once a thought moves from the unconscious to the conscious mind it becomes more malleable, which means that you can change it.

The first step in this process is to pause and pay attention to your thoughts. Once you capture them by being aware of what you're thinking, they will move from your unconscious mind to your conscious mind.

Step 2. Pray

> *"We demolish arguments and every pretension that sets itself up against the knowledge of God, and we take captive every thought to make it obedient to Christ."*
> 2 Corinthians 10:5 NIV

The second step in the process is to replace the toxic thoughts, fears, and concerns with the Word of God.

1. Choose a scripture, declaration, confession, or phrase that you will recite whenever you notice that fear rising up in you. I'll talk more about these fears later.

2. Take some time and journal what you believe God is showing you. What does He need you to learn? What is the need you have from God that you are seeking from food?

Step 3. Active Practice

> *"So also faith, if it does not have works (deeds and actions of obedience to back it up), by itself is destitute of power (inoperative, dead)."* James 2:17 (AMP)

As powerful as it feels to hear a word from God, if you don't practice and rehearse what you've learned you can easily return back to your faulty, toxic ways of thinking. In this phase, called Active Practice, you will symbolically and actively DO something physical to renew your mind and replace the toxic thought with a positive one. As you go about your day, every time you experience a toxic thought you will do your active practice. The goal of active practice is to engage as many senses as possible, as it will allow the habit to be processed deeper than if it were just verbalized alone. Here are some examples of active practice:

- taking a step forward
- putting your hands over your heart
- stomping on the toxic thought
- exalting the name of the Lord
- smile and visualize that God is pleased with you
- lift your hands in surrender
- clap your hands in victory
- sing a verse of a related song
- draw or sketch something
- visualize Jesus sitting beside you

On day three, you will decide what your 'active practice' will be. After day three, you can keep the same practice or you can try a different one. What's important is that you practice it every time you experience a toxic thought.

This ends section one. Know that I'm cheering you on in your Spirit-filled and sugar-free journey!!

Section 2. The Plan

This section contains 30 days that are broken down as follows:

1. **Three prep days**. The first three days are designed to set you up for success. There's a popular quote that says, 'failing to plan is planning to fail'. Take these days to prepare your kitchen and your meals.

2. **Three kick-start days**. Understand the 3-Step Reset© Plan and follow the three-day kick-start eating guide to quickly eliminate excess sugar from your body.

3. **21-day detox**. This is your 21-day sugar detox for your body as well as your 21-day plan to create new neural pathways so you can think differently instead of reverting to old habits and mindsets.

4. **Three post-detox days**. How many times have you counted down the days to finish your detox so you could jump right back into your old habits? Not this time! You'll learn how to slowly reintroduce some foods into your eating plan.

Prep Day 1: Set Yourself Up for Success

Scripture Reflection

"The plans of the diligent lead to profit as surely as haste leads to poverty." Proverbs 21:5 (NIV)

There's a popular quote that says, 'Failing to plan is planning to fail'. Regardless of how well your planning has or has not been to date, you're going to turn it up a notch.

Proverbs 21:5 teaches us that proper planning coupled with diligence will lead to success. As you kick off your journey, pray that you will be diligent in carrying out your plans. Pray that you will work heartily as unto the Lord (Colossians 3:23-24) and that you will give yourself the patience necessary for this process.

Rushing into the detox is a sure-fire way to get overwhelmed and set yourself up for a struggle. Whereas proper planning and preparation will make the process flow smoother, and you will enjoy the process so much more.

Prepare Your Heart

- Prepare your heart by praying.
- Pray that this will be a Spirit-led journey.
- Pray for the strength and determination that you will commit yourself whole-heartedly to the entire process.
- Pray for grace so that you will be patient with the process and not beat up on yourself.

- Pray for your success.
- Pray for other women around the world who are also on this journey
- Pray that you will make yourself a priority and give the program the time and effort it requires.

Prepare Others

- Have a conversation with family members who may be impacted and let them know what you're doing
- Make whatever adjustments you need to make so you're not tempted by their foods.
- Share your journey with a select few who will support you and hold you accountable.
- Pay attention to anyone who might potentially sabotage you, submit them to God in prayer, and have a plan for how you will handle these situations.

Prepare Your Mind

Pay attention to any allergies or dietary restrictions you may have.

- Be sure you've read the F.A.Q. in section one.
- Get familiar with the 3-Day Kickstart eating guide and the Spirit-Filled eating guide — especially you choose to create your own meal plan
- If you're starting to feel anxious about giving up your sugar, begin to practice the 3-Step Reset ©
- Begin to get excited about what's waiting for you on the other side of this detox.
- Read through the entire 'What to Expect in the Detox Program' so you're not caught off guard.

- Print your Active Practice worksheets found at spiritfilledandsugarfreebonus.com so you can track your progress and renew your mind.

- Prepare for some of the detox symptoms you may experience in the first few days (see 'What to Expect in the Detox Program'). It will pass.

- Prepare for a possible rollercoaster ride of emotions from "I got this," "This ain't so bad," to "I can't do this," "I need something sweet," to, "I'll never go back to sugar again." This is all part of the journey. Feel your feelings without judgment and turn them over to God.

Prepare Your Kitchen

- Go through your cupboards and read the labels to become familiar with the sugar content in the foods you eat.

- Get rid of all tempting foods.

- If you take medication, plan any adjustments that will need to be made.

- Go through your pantry and make a list of all the foods you already have in stock and which ones you will need to purchase.

- As you review the eating guides, make a list of foods you will substitute due to allergies or dietary restrictions.

- Can you pre-cook and portion out your snacks in Ziplock bags?

- Do you have proper storage containers?

- Make your shopping lists.

- If you plan to make any of the soups or salad dressings, make them ahead and freeze them if you won't be using them in the next few days.

Prepare Your Schedule

This is one of the biggest areas where people get tripped up. You have a tendency to underestimate how long it will take you to do things, and overestimate your capacity to get it done. This process will require additional time to read labels, shop, journal, and pray. If you're currently not practicing these habits, then you will need to make the time in your probably already busy schedule.

- When will you be cooking?
- When will you be grocery shopping?
- What day each week do you plan to do batch cooking?
- What time do you plan to eat your meals? Schedule a consistent time each day.
- What time each day will you be spending with the Lord and doing your daily devotions?
- Review your entire month and notice if there are any upcoming events that will require some extra planning (birthdays, graduations, etc.).
- Enjoy the journey!!

Prayer

"Lord, I admit that I'm not always diligent in my actions. I look for the easiest way, the fastest way, and the cheapest way sometimes, and it rarely works out well. As this new year begins, help me to be diligent in my planning as well as in everything else that I do. Keep me mindful that everything I do is to glorify You. Your Word reminds me of all of the benefits of the diligent person, and I want that to be me. I want to experience all the

fruits and benefits of a diligent person. In Your name, I pray. Amen!"

Additional Scriptures

"Whatever you do, work at it with all your heart, as working for the Lord, not for human masters, since you know that you will receive an inheritance from the Lord as a reward. It is the Lord Christ you are serving." Colossians 3:23-24 (NIV)

"He who has a slack hand becomes poor, But the hand of the diligent makes rich." Proverbs 10:4 (NKJV)

"The hand of the diligent will rule, But the lazy man will be put to forced labor." Proverbs 12:24 (NKJV)

"The soul of a lazy man desires, and has nothing; But the soul of the diligent shall be made rich." Proverbs 13:4 (NKJV)

Prep Day 2: The Science of Sugar

Scripture Reflection

"It is not good to eat much honey, nor is it glorious to seek one's own glory." Proverbs 25:27(ESV)

In Solomon's day honey was a prized commodity, and he reminds us that self-control is essential when eating it. Unfortunately, you now live in a society where almost all of your foods contain sugar, and manufacturers dupe you into eating foods designed to make you addicted to them for the sole purpose of consuming more.[9] How are you going to fight against this unseen weapon? By educating yourself on the dangers of these addictive foods.

We all get it — that strange, relentless feeling in your body that is difficult to pinpoint. It feels like a bit of anxiety, mixed with anticipation, mixed with yearning. It can show up after a meal when a certain emotion hits, or just out of the blue — it's sugar cravings. Its pull is relentless and can leave even the most strong-willed person feeling powerless.

Although overconsumption has always been a problem for us human beings, back in Solomon's day they did not have to contend with the issues of refined sugars that overstimulate your palate and lead to sugar cravings.

9 https://www.amazon.ca/Hooked-Food-Giants-Exploit-Addictions/dp/0771059604/ref=asc_df_0771059604/?tag=googleshopc0c-20&linkCode=df0&hvadid=578928242060&hvpos=&hvnetw=g&hvrand=13108023530697579488&hvpone=&hvptwo=&hvqmt=&hvdev=c&hvdvcmdl=&hvlocint=&hvlocphy=9000801&hvtargid=pla-1640264730892&psc=1

The culprit for these uncontrollable cravings can be blamed on the 'feel-good' neurotransmitter (a chemical that sends messages to the brain) called dopamine. You might have heard of it in relation to drug addicts. It helps control feelings of pleasure and reward. It's released when you exercise (ever heard of the runner's high?) but it's also released in response to the consumption of stimulants such as nicotine, caffeine, narcotics and, you guessed it, sugar.

This dopamine 'hit' you get when you eat sugar sends a signal to your brain to eat more and more sugar despite the often negative consequences. This means your attention can be drawn to sugary foods like cakes and chocolates even when you're not necessarily hungry.

Sugar contains no nutritional value, so it's pretty-much wasted calories that provide no nourishment for your body. That's one of the reasons why you can keep eating more and more sugar and never be satisfied. And to add insult to injury, sugar robs your body of other essential nutrients.

Reflect

1. Reflect on Solomon's simple statement that it is not good to eat too much honey. What effects does sugar have on your body specifically?

2. How much sugar do you estimate you consume each day? If you use MyFitnessPal, it will tell you exactly based on the foods you eat.

3. What are your sugar triggers?

Prayer

"Dear Lord, I confess to trying really hard to find something that will fill the void. Foods that contain high amounts of sugar are so appealing to me. I crave them and seek them out, but no more, Lord. Knowledge is power, and now that I know better, I will commit to doing better. These counterfeits only provide a temporary fix and work as a band-aid, giving me short-lived relief and tricking me into thinking that all I need is 'just one

more' to feel better. But in all my efforts, all I've ultimately found is frustration, pain, and more problems. Lord, I confess that I've bought into the lies that say I need some external thing to complete me, although I know You. I confess that I have fallen short of letting You be the Lord over my health. With Your help and strength, I will overcome my dependence on sugar. On this day, I invite Your Holy Spirit to take over and give me a spirit of self-control. In Your Holy Name, I pray. Amen."

What to Do Today

- Understand the possible withdrawal effects discussed in section one and make sure you have a plan in place.
- If you have not already done so, increase your consumption of water and herbal teas.
- Do you have all of the necessary ingredients to prepare for the 3-Day Kickstart? Or if you plan to prepare your own meals, what will you be preparing?
- Begin to decrease your sugar consumption to minimize the withdrawal effects.
- Prepare any snacks, homemade salad dressings, or soups in advance.
- Get a good night's sleep (at least seven hours).
- Drink seven to eight cups of water.

Additional Scriptures

"Whoever has no rule over his own spirit is like a city broken down, without walls." Proverbs 25:28 (KJV)

"Their end is destruction, their god is their belly, and they glory in their shame, with minds set on earthly things." Philippians 3:19 (ESV)

""All things are lawful for me," but not all things are helpful.
"All things are lawful for me," but I will not be dominated by
anything." 1 Cor 6:12 (ESV)

https://journals.lww.com/co-clinicalnutrition/Abstract/2013/07000/
Sugar_addiction___pushing_the_drug_sugar_analogy_to.11.aspx

Prep Day 3: Meal Planning

Scripture Reflection

"The soul of a lazy man desires, and has nothing; But the soul of the diligent shall be made rich." Proverbs 13:4 (NKJV)

If you're not intentional about planning what to eat, you will always take the path of least resistance. This means that you will do what's quick and easy. This is great if you want to quickly microwave your dinner, but not so good for a long term strategy of good health

To be successful at planning healthy meals with minimal amounts of sugar, taking the time to plan is essential; otherwise, you'll keep reverting to old habits. To eat healthily, being intentional, diligent, and proactive will help you become consistent in your efforts.

Begin to prepare by doing the following:

- Go through your cupboards and read the labels to become familiar with the sugar content in the foods you eat.
- Get rid of all tempting or trigger foods.
- If you take medication, plan any adjustments that will need to be made.
- Go through your pantry and make a list of all the foods you already have in stock and which ones you will need to purchase.
- As you review the eating guides, make a list of foods you will substitute due to allergies, taste preferences, or dietary restrictions.

- If you're following your own meal plan, plan out your entire day so you know what 50 carb grams look like for the 3-day kickstart.
- What foods will you pre-cook and what snacks will you portion out into snack zip lock bags?
- Do you have proper storage containers?
- Make your shopping list.

Planning Your Carbohydrates

After the 3-day kickstart, begin to plan what you will be eating during the 21-day sugar detox.

In order to do this, you may choose to track how many carbohydrates you're currently consuming using a logging app such as myfitnesspal. The free version will tell you how many grams of carbohydrates you're currently consuming, or you can just follow the suggested eating guides I recommend in section 3.

Reflect

1. What exactly will you be eating during the 3-day kickstart?

2. What foods have you substituted?

3. What foods, salad dressings, or soups will you batch cook?

What To Do Today

- Prepare some of your meals for the 3-day kickstart or the 21-day detox and freeze some meals for next week.

- Have a clear understanding of what 50 grams of carbohydrates looks like each day for the first three days of your kickstart.

- Continue to decrease your sugar consumption to minimize the withdrawal effects.

- Prepare any snacks, homemade salad dressings, or soups in advance.

- Get a good night's sleep (at least seven hours).

- Drink seven to eight cups of water.

Prayer

"Father God, I thank You for this day that You have made. As I prepare for this journey, I have a lot of apprehension and fears. I know that this way of eating will bring life to my body, but I'm so afraid of feeling deprived. So remind me today that my satisfaction is in You, Lord. It's Your Word that I feast on each day (Jeremiah 15:16-NIV) that says, "when your words came, I ate them; they were my joy and my heart's delight, for I bear your name, LORD God Almighty". Let that be my testimony. You are enough. I delight in You. I find my joy in You. There's nothing sweeter than You. Help me to better prepare for what is to come so that I'm not caught off guard. I know that proper planning will make this journey so much smoother, so I commit this day to You. In Jesus' Name. Amen!"

Additional Scriptures

"Commit your actions to the Lord, and your plans will succeed." Proverbs 16:3 (NLT)

"Careful planning puts you ahead in the long run; hurry and scurry puts you further behind." Proverbs 21:5 (MSG)

Kickstart Day 1: Are You Ready?

Are you ready to demolish every idea, opinion, and worldview that does not include Christ as the cornerstone of your life? It's time to take every thought captive and make them obedient to Christ. It's time to confront lies with God's truth. It's time to use your spiritual weapons to pull down strongholds. As you are transformed by the renewing of your mind you will cling desperately to God, trusting His divine Word. This is where true freedom lies. Today you will begin to understand the 3-Step Reset Process you will use for renewing your mind.

Reflect

This detox will teach you how to replace toxic thoughts with healthy, positive thoughts. It will involve 5-10 minutes of focused, conscious exercises each day to retrain your brain to think differently.

This is a 3-Step Reset process:

Step 1. Pause

Step 2. Pray

Step 3. Active Practice

Today you will focus on PAUSE. The first three lessons will take a bit longer than usual because you're going to spend some time and identify what toxic thoughts you will be working on capturing during this challenge. This is the first important step.

Step 1. Pause

Because most of your thoughts are unconscious, logically most of your actions and behaviors will also be unconscious, thus impossible to control. However, once a thought moves from the unconscious to the conscious mind, it becomes more malleable, which means that you can change it.

The first step in this process is to pause, and pay attention to your thoughts. Simply stop and take about five slow, deep breaths in through your nose and out through your mouth. This pause helps you to develop an awareness of your thoughts that lead you astray. It will also help you to balance your nervous system as you reconnect and realign your body, soul, and spirit. Again, you see your Father's infinite wisdom in His Word as He lovingly commands you to "Be still" (Psalm 46:10). It's in the stillness that you can calm the noise and invite the wisdom that comes from the Holy Spirit that aligns with your spirit.

When you don't pause, you remain swirling in the mess of your mind. And too often you're not aware of the limiting thoughts and beliefs that lead you astray such as:

- I've failed so many times in the past, why will I be successful this time?
- I can't do this.
- What if I put the weight back on?
- What if I fail?
- What if it takes too much time to prepare everything?
- How will I cope without sugar?
- What if I get overwhelmed?

Simply pausing will help you to reconnect with your spirit, which will speak truth, wisdom, encouragement, or whatever you need in the given moment.

For today, you will answer a series of questions (see below) to help develop awareness of the thoughts that lead you astray. Once you capture them, they will move from your unconscious mind to your conscious mind. Know that this process happens over time, and you may not initially be aware of what thoughts are leading you astray. Be kind to yourself and accept that you might not be able to capture your thoughts right away. It will take some practice.

To begin this process, invite the Holy Spirit to search your heart. Read this scripture and then ask yourself the following questions:

> "Search me [thoroughly], O God, and know my heart; Test me and know my anxious thoughts; And see if there is any wicked or hurtful way in me, and lead me in the everlasting way." Psalms 139:23-24 (AMP)

1. Close your eyes right now and tune in to God's presence. What feelings do you experience? What do you hear God telling you? What do you see? Write it in a journal.

2. Write down the main fears that come to mind when you think about releasing weight.

3. As you think about this 30-day detox, what are you afraid of?

4. What are your biggest concerns?

5. What are all the different thoughts floating around in your mind? Capture them and journal them.

Prayer

"Dear Lord, I thank You for your presence today and always! Almighty God, I'm leaning on Your guidance with an open heart and mind as I prepare to begin this new month. I come before You, confessing that my thinking has been out of alignment with Your Word and with who You made me to be. Lord, I repent of and renounce that wrong thinking that has kept me stuck in my weight releasing journey, and in general. I invite Your Holy Spirit to reveal to me the toxic thoughts to capture and bring to You Lord, so that they may be brought into alignment with, and obedience to, Your truth. My fears of letting go, Lord, are coming up, but I trust and believe that Your power to carry me is so much greater! Thank You in advance for illuminating my path. In Jesus' mighty Name. Amen."

Planning for Tomorrow

- Have you identified some of the toxic thoughts that are running through your mind?
- Have you planned your meals?

Kickstart Day 2: Choose Your Weapon

Scripture Reflection

"The weapons we fight with are not the weapons of the world. On the contrary, they have divine power to demolish strongholds." 2 Corinthians 10:4 (NIV)

In 1 Samuel 17:45 (NIV); "David said to the Philistine, *"You come against me with sword and spear and javelin, but I come against you in the name of the LORD Almighty, the God of the armies of Israel.""* That's analogous to bringing a knife to a gunfight — no contest.

Yet, that's what you do every day as you try to use your own strength to handle your strongholds. God has given us powerful spiritual weapons such as prayer, His Word, and the Holy Spirit. Our puny artillery is nothing compared to the powerful spiritual weapons we have in God.

It's time to use your God-given weapons! That, my friend, is how you destroy every proud obstacle that keeps you from knowing God.

Have a powerful Day 2 as you arm yourself with your weapons for battle!

Reflect

How did you make out yesterday on capturing your thoughts?

TO RECAP: Yesterday, you brought some of your toxic thoughts from your unconscious mind to your consciousness by intentionally focusing on them and seeking the Holy Spirit. Once

a thought moves from the unconscious to the conscious mind it becomes more malleable, which means that you can change it.

One of our Weight Loss, God's Way program members shared this from yesterday's exercise:

"During the exercise, I realized I had some fears going into this that I didn't know I had. Such as, I'm afraid if I lose the weight my husband and family will think less of me. Like, I'm vain somehow. I know it's just the enemy. And so again just practicing those scriptures and asking God to continue searching my heart, He did reveal that when I have thoughts such as these, they are hurtful thoughts towards myself and towards God's plans for me. I never ever viewed it that way, until this morning."

To recap, renewing your mind is a 3-Step Reset© process:

Step 1. Pause

Step 2. Pray

Step 3. Active Practice

Today you will focus on PRAY.

Step 2. Pray

You are going to begin to use your spiritual weapons to replace your limiting or toxic thoughts with healthy, God-centered thoughts.

The Amplified Version of Hebrews 4:12 says this:

"For the Word of God is living and active and full of power [making it operative, energizing, and effective]. It is sharper than any two-edged sword, penetrating as far as the division of the soul and spirit [the completeness of a person], and of both joints and marrow [the

deepest parts of our nature], exposing and judging the very thoughts and intentions of the heart."

The verse teaches that it's only the power of God's Word that can perform the necessary separation of your soul and spirit. God's word is so sharp it can divide and discern the heart.

When the Word of God exposes and judges your intentions, it will show you what thoughts line up with the Word of God and what thoughts arise from your soulish nature. Your solution to overcome strongholds is to be led by the spirit so that you will not give rise to your flesh. (Romans 8:6, my paraphrase)

You will begin the process today as you spend some time and select a couple of scriptures, confession, declarations, and/or prayers that you will use to combat the toxic fears and thoughts that you identified yesterday.

For example, if yesterday you identified that you feared that you would fail, you could select one of the following:

"I am confident that God will perfect the work He has begun in me" *(Philippians 1:6 paraphrase).*

"I have not been given a spirit of fear, but of power, love and self-discipline" *(2 Timothy 1:7 paraphrase).*

Or, you could say:

"Lord, I choose to stand in Your truth and not worry about what's happening around me. You are in control and that's all that matters."

Memorize one of the above (or select your own) and practice rehearsing it as you move about your day today. When you notice a toxic thought arise, recite the prayer (or declaration).

Depending on the situation, your spiritual weapons may include powerful phrases, prayers, declarations, and/or confession. Here are some examples:

Phrases

These are simple phrases that you can use to reframe a conversation or when you just need to show yourself grace and compassion. A reframe is another perspective or point of view that you can repeat to yourself when you find yourself repeating familiar phrases or negative self-talk. For example, when you find yourself judging yourself for not trying hard enough or for missing the mark, you might say to yourself, "I am doing the best that I can."

Here are some more phrases or declarations...

"I'm striving for progress, not perfection."

"Perfection focuses on me, not God."

"God is in control."

"Everything is as it should be."

"There is nothing to worry about."

"What's important is what God thinks of me."

"My assignment is to please God, not man."

"I am loved lavishly by God."

"I deserve to take care of myself."

"I choose to live in the solution and not the problem."

"I am responsible for my life."

"I can take action without knowing all the facts."

"I am loved just the way I am."

"I don't need to know."

"I am loved and admired by God."

"I have nothing to prove."

"I am made in the image of God."

"God will fight for me."

"I am not my past."

Declarations

These declarations are grounded in Scripture, and you can use them to renew your mind when you find yourself operating out of a spirit of perfectionism, people-pleasing, or control. This is a short prayer to God that you can repeat throughout the day as many times as you need. Keep it on your phone or somewhere that you can quickly access it when you need it. Here are a few examples:

"Thank You, God, that You are healing/helping/strengthening/ working on me according to Your perfect schedule."

"Your grace is sufficient."

"Lord, I choose to stand in Your truth and not worry about what's happening around me. You are in control and that's all that matters."

"Lord, I thank You that my only desire is to please You and not man."

"Lord, I thank You that you paid the ultimate sacrifice for me. I am worthy and free to live the life You designed for me to live."

"Lord, I thank You that my greatest desire is to know YOU intimately and earnestly. I see myself as valuable and beautiful just as You see me."

Scriptures/Confessions

These are perfect to use when you're journaling or just need to be strengthened by God's Word.

- I am confident that God will perfect the work He has begun in me (Phil. 1:6).
- I have not been given a spirit of fear, but of power, love, and self-discipline (2 Tim. 1:7).
- I am given God's glorious grace lavishly and without restriction (Eph. 1:5,8).
- I am assured all things work together for good (Rom. 8:28).
- I have peace (Eph. 2:14).
- I am safe (I Jn. 5:18).
- I can give thanks for everything (Eph. 5:20).
- I don't have to always have my own agenda (Eph. 5:21).
- I am chosen and dearly loved by God (1 Thes. 1:4).
- I am created in the image of God (2 Cor. 4:4).
- I am not helpless (Phil. 4:13).
- I am blessed in the heavenly realms with every spiritual blessing (Eph. 1:3).
- I am forgiven (Eph. 1:8; Col. 1:14).
- I have a purpose (Eph. 1:9 & 3:11).

- I can be kind and compassionate to others (Eph. 4:32).
- I am set free (Rom. 8:2; Jn. 8:32).
- My heart and mind are protected with God's peace (Phil. 4:7).
- Possess the mind of Christ (I Cor. 2:16).

End your time today in prayer:

Prayer

"Dear Lord, good morning. Thank You for another day with You as You reveal to me those thoughts that don't agree with You — who You say I am and the good plan You have for my life. Lord, please give me the courage and assurance of David to call on You and Your Word to fight against and replace toxic thoughts. Help me to know that my best human efforts are no match for this battle, but I can take heart because Your awesome, supernatural power has already won!! Lord, today, use me and my frailty as a vehicle for Your mighty artillery to dismantle the strongholds in my mind! I am picking up the double-edged sword of Your Spirit to fight this battle. When I waver, remind me, please, that lies and toxic thoughts have no place in my mind. I have the mind of Christ, and in the holy Name of Jesus, I allow only thoughts that are of You to take root today! Thank You, Lord, that I am worth fighting for. Amen."

Planning for Tomorrow

- Have you identified some of the toxic thoughts that are running through your mind?
- Have you reviewed the eating guide for tomorrow?
- Do you have all of the foods you need?

Kickstart Day 3: Faith in Action

Scripture Reflection

"I will praise you as long as I live, and in your name I will lift up my hands." Psalms 63:4 (NIV)

David lifted his hands and prayed Psalms 63:4; Moses and Joshua removed their shoes while standing on holy ground (Exodus 3:5); Joshua stretched a spear toward the city of Ai (see Joshua 8:18–19); Isaiah wrote the name *Mahershalalhashbaz* upon a scroll and then united with his wife (Isaiah 8:1–4); Jeremiah placed stones in a brick kiln (Jeremiah 43:8–13).

What about you? You sometimes hold your hands over your heart when you recite the anthem, you clap to show your gratitude and appreciation for things, or you may snap an elastic band on your wrist to help change negative behavior.

Whether biblical or in your life today, certain actions, gestures, movements, or postures have very practical purposes and symbolic meanings. Gestures like these can improve memory, learning, problem-solving, and communication.

In today's lesson, you're going to create your own gestures called 'active practices,' which you will use to help crystallize your prayers and declarations.

Reflect

TO RECAP: Day 1 you focused on pausing and capturing your toxic thoughts; Day 2 you prayed and invited the Holy Spirit to help you with your toxic thoughts. Today you're going to practice 'a specific action' in response to your toxic thoughts. Step 3 is known as 'Active Practice'.

Step 3. Active Practice

'Active Practice' is a powerful tool to help you retrain your brain to think positive, healthy thoughts.

You can decide what your active practice is going to be. You can choose just one and repeat it every day during the rest of the program, or you can select a different one based on the toxic thought.

Here's how it works. Whenever you notice a toxic thought, you will remember one of your declarations that you selected yesterday. Then, you will select an 'active practice' that will help you to see yourself breaking free from the toxic thought.

Do your active practice 5-10 times per day. Practice them consistently in order for a new habit to be formed.

Use the worksheet in the appendix to help you record how many times per day you completed your active practice. Keep the checklist handy throughout the day.

Here are some examples of active practice:

- Take a step forward to show that you are walking out of your past.
- Put your hands over your heart to show how much you are loved by God.
- Stomp on the toxic thought to remove it from your life.
- Exalt the Name of the Lord.
- Smile and visualize that God is pleased with you.
- Lift your hands to the sky in surrender.
- Clap your hands in victory.
- Sing a verse of a related song.

- Draw or sketch something.
- Visualize Jesus sitting beside you.

Reflect:

My active practice will be:

End your time today in prayer:

Prayer

"Dear Lord, I praise You today for Your goodness! Thank You for giving me a powerful body that moves and for the intricate ways You've wired it to connect to my mind. Help me, Lord, to use this body to move in harmony with You and Your truth. Create in my mind new pathways that solidify the new truths I'm learning. Please clear away the debris of the old, worn out, unhelpful patterns and let something new and beautiful flourish in me! As I focus on practicing using my spiritual weaponry, show me ways I can move my body that will help my faith to grow. I trust You, Jesus, that as I move, You act. And when I take action, You move in my life! In Your awesome Name, I thank You and praise You, Lord! Amen."

Planning for Tomorrow

- Have you selected an active practice?
- Have you downloaded the Active Practice Checklist? (spiritfilledandsugarfreebonus.com)
- Have you made the necessary adjustments as a result of your day yesterday?
- Do you have all of the foods you need?

Day 1: Let Him Lead

Scripture Reflection

"Search me, O God, and know my heart; Try me and know my anxious thoughts; And see if there be any hurtful way in me, and lead me in the everlasting way."
~ Psalms 139:23-24(NASB 1995)

As a teenager I remember being so moved by the poem, *Footprints in the Sand* (for which at least a dozen people claimed credit).

One night I dreamed a dream.
As I was walking along the beach with my Lord.
Across the dark sky flashed scenes from my life.
For each scene, I noticed two sets of footprints in the sand,
One belonging to me and one to my Lord.

After the last scene of my life flashed before me,
I looked back at the footprints in the sand.
I noticed that at many times along the path of my life,
especially at the very lowest and saddest times,
there was only one set of footprints.

This really troubled me, so I asked the Lord about it.
"Lord, you said once I decided to follow you,
You'd walk with me all the way.
But I noticed that during the saddest and most troublesome times of my life,
there was only one set of footprints.
I don't understand why, when I needed You the most, You would leave me."

He whispered, "My precious child, I love you and will never leave you
Never, ever, during your trials and testings.
When you saw only one set of footprints,
It was then that I carried you."

So beautiful, so simple! Yet sadly, many choose to walk the journey alone. You spend much of your life frustrated with yourself. You constantly beat up on yourself for continually making the same mistakes over and over, and can never seem to gain any traction. Much like your battles with sugar, it seems like a never-ending rollercoaster ride.

But you were never meant to walk this journey alone, and you were never meant to try to figure everything out. True insight about yourself, what drives you, what triggers your cravings, your body, your health, and your life only comes about when you learn who you are in Christ.

God alone can teach you why you do what you do and why you continually spin your wheels or sabotage yourself. He will give you insight into yourself and show you just how significant, powerful, and purposeful you are.

That's why David first asks God to search him, then to LEAD him. He longs to lead you if you will allow Him. God yearns for you to gain insight and see through the lens of the Holy Spirit and His Word — that's where your breakthrough will come.

Reflect:

As you read the scripture above and reflect on how much time you spend trying to fix yourself, journal what comes to mind.

Now that you've spent the time understanding what the three steps are to renewing your mind and stopping a toxic thought or limiting belief, for the rest of the detox you will be rehearsing these three steps.

Step 1: Pause. This is where you will pause and become aware of the thoughts that are floating around in your mind and understand what it is doing in your life. Reflect on the impact that this thought has on your life. Record it in a journal.

Step 2: Pray. Home in on a dominant thought and use your spiritual weapons of prayer, Scripture, and declarations to change the thought.

Step 3: Active Practice. In this step, you will practice a symbolic action in response to the toxic thought whenever it pops into your head. You can choose the same active action you practiced yesterday or choose a new one. Record them on your Active Practice Tracker and track how many times you performed it. The more you can visualize, the more you will build healthier thoughts.

Reflect on how much time you spend trying to fix yourself. Let God know that you are ready to **let Him lead**. Journal your thoughts/insights.

Pray:

"Dear Beautiful Jesus,

Today I thank You for Your unconditional love. It astounds me that You would choose to love me in all my sin and imperfection. Lord, my pride, my vanity, my fear of what people think, my self-centeredness — these are things I'm not proud of and I confess them to You, trusting in Your compassionate heart. It's difficult for me to trust because I've been hurt, and I've learned in the world that my flaws are unacceptable. Lord Jesus, help me to receive the fullness of the incomprehensible gift of Your grace — not just in my mind, but let it take up residence in my heart and be the wellspring from which I live my life for You. My

desire is to follow Your lead, my Good Shepherd, and to believe Your truth about who I am in You. Please search my heart, Lord, and reveal to me the things that You are changing in me, giving me insight into the things that need my attention. Allow me to rest, trusting in Your timing that You will reveal that which You choose at the perfect time. Please give me Your eyes to accept and love myself (and others) exactly the way that I am today — just the way You do — and help me to follow You in the way everlasting. In the magnificent Name of Jesus. Amen."

What To Do Today

- Check in with any withdrawal symptoms you may be feeling. How are you managing them?
- Track your active practice today.
- Drink seven to eight cups of water.
- Get a good night's sleep (at least seven hours).
- Can you begin to carve out some time for light exercise?

Planning for Tomorrow

- Have you begun to prepare your meals for next week? What will you be eating?
- Review the eating guide. Do you have all of the foods you need?
- Do you know exactly what you will be eating tomorrow?

Additional Scriptures:

"Always let him lead you, and he will clear the road for you to follow." Proverbs 3:6 (CEV)

"A man's heart deviseth his way: but the LORD directeth his steps." Proverbs 16:9 (KJV)

"I will instruct thee and teach thee in the way which thou shalt go: I will guide thee with mine eye."
Proverbs 32:8 (KJV)

Day 2: God is Here

Scripture Reflection

"Where can I go from your Spirit? Or where can I flee from your presence?" Psalms 139:7(ESV)

Most people never take the time to think about what they're thinking about. If you were to tune in to your thoughts, you would realize so much about yourself.

You would realize that you're either worrying about things in the past (I wish that I had exercised yesterday, or I shouldn't have eaten that cake), or you're worrying about the future (I've got to get to the gym, or I've got to get my eating under control). Yet, the place where you're most powerful and effective is the one place you spend the least amount of time and that's in the here and now — the present.

Living with the focus on the 'now' can be demanding because it challenges you to remain present to your thoughts and your feelings with the continual practice of staying present to His presence. It takes vigilance and sober-mindedness (1 Peter 5:6-7). But when your heart is committed to the Lord you feel at peace, knowing that the Lord finds you and is always ready and available to speak to you in this present moment.

God is here with you right now and He wants to make His presence known. Call on Him whenever you need Him. If you're struggling with sugar cravings or you want to eat emotionally, let Him know. If you're feeling weak, let Him strengthen you. Maybe you can't feel Him, but He's here. Loving you, encouraging you, and affirming you. He's not in the past looking back at your mistakes or in the future pressuring you to do better. He is here, right now, right where you are. The Bible says in His presence

there is the fullness of joy. Living in the present is where the presence of the Lord is — filled with love, peace, power, and pleasure.

Reflect:

Step 1: Pause. Tune in to this present moment. What are you thinking right now? What thoughts keep taking you out of this present moment? What thoughts come to mind as you read the scripture in Psalms 139:7? As you tune in to God's presence right this very second, how does that impact your thinking? Does it change your perspective? Journal your thoughts.

Step 2: Pray. Is this the same toxic thought that you had over the previous days, or is this a new toxic thought? If it's new just record it, but don't worry about trying to change it. Just notice it without judgment and thank God for the revelation.

If it's similar to the previous recurring toxic thought(s), then arm yourself with your scriptures/declarations/confessions that you prepared on Day 2 and speak out loud to your thought. Listen to the words that you are saying to yourself.

Step 3: Active Practice. As you go about your day, be sure to do your active practice. The more you can do it, the more successful you will become at eliminating your toxic thoughts. You can choose the same active action you practiced yesterday or choose a new one. Record it on your Active Practice Tracker. If you have not printed it out yet, go to spiritfilledandsugarfreebonus.com and track how many times you performed it.

Pray:

"Good morning, Lord! Thank You so much that you are here with me RIGHT NOW and always! Please forgive me that sometimes I forget You're there. Forgive me also for the way I spend time afraid of the future and ashamed of the past, rather than focusing on the gift of the present moment. Lord, I'm turning toward You here and now in gratitude that You want to be with me in every single moment. Please increase my faith in You to provide for me and attend to my every need so that I can enjoy the life You've given me to live today. Help me to be aware of Your Holy Spirit dwelling in me — encouraging, convicting, and affirming me. As I go through my day let me put my hand in Yours and walk step-by-step with You, day-by-day, minute-by-minute, second-by-second, trusting in Your power to carry me through each and every moment. Fill me with Your joy and peace, Lord. You came so that I can have a full life, so please break the chains of worry and shame that keep me bound. In Your holy Name, I pray. Amen."

What To Do Today:

- Track your active practice today.
- Drink seven to eight cups of water.
- Get a good night's sleep (at least seven hours).
- Can you begin to carve out some time for light exercise?

Planning for Tomorrow:

- Review the eating guide. Do you have all of the foods you need?
- Have you reviewed the eating guide and made any necessary adjustments?

Additional Scriptures

"Have I not commanded you? Be strong and courageous. Do not be frightened, and do not be dismayed, for the Lord your God is with you wherever you go." Joshua 1:9 (ESV)

"Fear not, for I am with you; be not dismayed, for I am your God; I will strengthen you, I will help you, I will uphold you with my righteous right hand." Isaiah 41:10 (ESV)

"Do you not know that you are God's temple and that God's Spirit dwells in you?" 1 Corinthians 3:16 (ESV)

Day 3: Don't Quit

Scripture Reflection

*"Let us not become weary in doing good, for at the proper
time we will reap a harvest if we do not give up."*
Galatians 6:9(NIV)

By about now, the warm fuzzy feelings of starting a new
challenge such as this sugar detox may have already started to
wear off.

It's totally normal and necessary as the 'feel-good' chemicals
return to their normal state. Now is where the rubber meets the
road; now is where you turn over the reins to God and let Him
take over from here. Too often you see change as a one-time
deal. You identify the problem, try to fix it, realize it's not as
easy as you thought, then experience setbacks, give up, and say,
'it did not work.'

But that's not how the heart of God operates. God is continually
transforming you day by day. There is never a point when
you're done. Sure, you may achieve your ideal weight, but God
wants so much more from you than to achieve a certain number
on the scale. Everything that you do has eternal implications,
and that's why you will always keep on learning, growing, and
drawing closer to God.

Scripture teaches us that '*at the proper time*' we will reap a
harvest. That 'proper time' will come once you choose to
willingly surrender and submit; once you learn to trust God to
meet all of your needs. Don't quit before your harvest!

Reflect

Step 1: Pause. Tune in to this present moment. Are old, familiar feelings of the past beginning to rear their ugly heads? Does any part of this journey feel familiar? You may have been here before, but remind yourself that this time it's different. You are changing the toxic thoughts of failure, discouragement, doubt and fear, and slowly replacing it with positive, healthy habits. Even though you can't see it or 'feel' it, believe that change is happening. Capture any old familiar feelings that are starting to creep in. Journal them.

Step 2: Pray. Write out a scripture, declaration, or confession that you will use to cancel out the old, familiar thoughts or feelings.

Step 3: Active Practice. As you go about your day, be sure to do your active practice. The more you can do it, the more successful you will become at eliminating your toxic thoughts. Is there a specific active practice you will do for this new toxic thought? If not, continue in the active practice that you've been doing for the last two days. Record it on your Active Practice Tracker and track how many times you performed it.

Prayer

"Dear Lord, Wow! How I need You today! The funny thing is, sometimes I think I've got this. At times, I don't think I need You that much, especially during the glow of a new challenge like this detox, and I'm so sorry about that. By now, the newness of this thing has worn off, and I'm still left here with myself. And this self NEEDS You, big time! Lord, please help me to persevere. Sink it into my spirit that earthly life is truly an unending series of learning experiences and not a performance. Help me to toss out the measuring stick and to trust You in this process as You lovingly refine me. You promise to transform me into Your image with ever-increasing glory by Your Spirit. Lord, tune me into Your Holy Spirit today. Help me be present today to this process, to my thoughts, and my feelings. Thank You for accepting and loving me exactly the way I am today, so much that You refuse to leave me here. God, in Your precious Son's Name, I declare my commitment to persevere on this journey! I am in this with You, my Lord!!! I want the harvest that You have planned for me! Amen."

What To Do Today

- Check in with any withdrawal symptoms you may be feeling. How are you managing them?
- Track your active practice today.
- Drink seven to eight cups of water.

- Get a good night's sleep (at least seven hours).
- Can you begin to carve out some time for light exercise?

Planning for Tomorrow

- Have you begun to prepare your meals for next week? What will you be eating?
- Review the eating guide. Do you have all of the foods you need?
- Do you know exactly what you will be eating tomorrow?

Additional Scriptures

"Blessed is the man who remains steadfast under trial, for when he has stood the test he will receive the crown of life, which God has promised to those who love him."
James 1:12 (ESV)

"Therefore, since we are surrounded by so great a cloud of witnesses, let us also lay aside every weight, and sin which clings so closely, and let us run with endurance the race that is set before us." Hebrews 12:1 (ESV)

"For you have need of endurance, so that when you have done the will of God you may receive what is promised."
Hebrews 10:36 (NIV)

Day 4: Feelings Aren't Facts

Scripture Reflection

"Even if we feel guilty, God is greater than our feelings, and He knows everything." 1 John 3:20 (NLT)

Do you ever FEEL guilty for breaking your sugar boundaries? Maybe you're feeling this right now and are ready to throw your hands in the air and say, "Here I go again." Or, "This always happens to me." Your conscience can plague you with so much guilt that often you go to bed every night feeling condemned and wake up the next morning feeling the same way.

Guilt is a form of emotional self-punishment and self-condemnation of your worth and value. It's an emotion that says that I did something wrong.

- Guilt says that you are not worthy; not valuable enough to claim any of God's promises.

- It tells you that you do not deserve God's grace, but instead, you should feel bad whenever you miss the mark.

- Guilt tries to control you into taking action, but feelings are not reliable sources of motivation or inspiration. Feelings are, well, just feelings that can change moment by moment.

In the scripture above, John offers an escape from this torture chamber of your mind where guilt resides. He reminds you to set your hearts on God's love. You free your mind by realizing that your feelings aren't facts; therefore, they are not great decision-makers. You free your mind by recognizing God's voice over the voice of guilt and condemnation. God's voice does

not produce guilt (Romans 8:1). His voice is one of assurance and comfort.

Choose to follow God's will for your life and refuse to let your feelings dictate how you should or should not respond. Remember, ninty-nine percent of guilt has nothing to do with reality, so refuse to give it a foothold in your life. Let the Word of God dictate your decisions, then set your mind to be a blessing to make the right choices that honor God.

Reflect

Step 1: Pause. Where do your feelings of guilt arise on this health journey? Capture every guilty thought that you experience. In light of the scripture above, how does it change your guilty feelings? Take a few minutes and journal what makes you feel guilty.

Step 2: Pray. Review the scriptures that you've been studying over the last three days. Can you apply those scriptures to your feelings of guilt? Do you need to select a new scripture?

Step 3: Active Practice. As you go about your day, be sure to do your active practices. The more you can do it, the more successful you will become at eliminating your toxic thoughts. Is there a specific active practice you will do for this new toxic thought? If not, continue in the active practice that you've been doing for the last three days. Record it on your Active Practice Tracker and track how many times you performed it.

A great active practice for today's lesson is to visualize taking all of your guilt and condemnation and placing it at the feet of Jesus.

Prayer

"Dear Lord, thank You that You are so much greater than my feelings!! I've been dragged around by them into all kinds of situations that have left me full of shame and guilt. In many ways, God, I have made my feelings my Lord and let them rule over me in the place You belong as my only authority. I've done what I hate so many times because of my feelings — usually trying to avoid the ones that feel awful, but sometimes just to enjoy the ones that feel great. Please forgive me, Lord! Today, I am trusting in Your unconditional love and in the knowledge that You are so much greater than my feelings! Help me please to trust in You when I start to feel tempted to let my feelings be my boss. Reassure me in my hour (or split second!) of need that Your ways are so much greater than mine, and that includes my feelings. Help me to hold in tension the unpleasant feelings and Your unconditional love. Give me the patience to pause before acting on them, allowing them to just be. My desire is to grow so close to You and to know You so intimately and closely, sweet Lord! Instead of stuffing down and burying them, Lord, I will trust You with my feelings and experience the freedom, peace, and joy that Your compassion brings! You are truly awesome, God! In Jesus' Name. Amen!"

What To Do Today

- Start your morning with a glass of lemon or ACV (apple cider vinegar) water.
- Have you identified any feelings of guilt? What scripture have you used to combat them?
- What adjustments do you need to make as a result of today?
- Track your active practice today.
- Drink seven to eight cups of water.
- Get a good night's sleep (at least seven hours).
- Can you begin to carve out some time for light exercise?

Planning for Tomorrow

- Have you begun to prepare your meals for next week? What will you be eating?
- Review the eating guide. Do you have all of the foods you need?
- Do you know exactly what you will be eating tomorrow?

Additional Scriptures

"Therefore, there is now no condemnation for those who are in Christ Jesus." Romans 8:1 (NIV)

"Therefore, since we have been justified by faith, we have peace with God through our Lord Jesus Christ." Romans 5:1 (ESV)

"For the Spirit God gave us does not make us timid, but gives us power, love and self-discipline." 2 Timothy 1:7 (NIV)

"... for all have sinned and fall short of the glory of God. . ."
Romans 3:23 (NIV)

Day 5: Deliverance from Double-mindedness

Scripture Reflection

"For let not that man suppose that he will receive anything from the Lord; he is a double-minded man, unstable in all his ways." James 1:7-8 (NKJV)

James uses the word 'double-minded' to describe someone who is divided by his interests or loyalties — wavering, uncertain, two-faced, half-hearted.

Unconsciously, many people are double-minded when it comes to reaching your health goals. Here's why:

- You want to kick the sugar habit but you don't want to feel deprived.

- You want to eliminate sugar from your life but you don't want to take the time to plan and prepare.

- You want to release weight but are afraid that you will be judged by others for being vain.

- You want to release weight but fear the work it will take to maintain it.

- You want to release weight but don't want to give up your current lifestyle.

- You want to release weight but you fear the additional responsibility that may come with the 'new you.'

Regardless of what your reason is, one thing's for sure: if your mind is not clear on your goal, you will not receive it. It's called cognitive dissonance, and it explains the anxiety that arises

when you hold two conflicting thoughts in your mind at the same time, as in all the examples above.

This anxiety and tension are what will keep you from your goals.

Why? God has given you a sound mind (2 Tim 1:7); one that is orderly and not confused. Once you're resolute in what you want God will be with you, but you have to decide what you really want first. This cognitive dissonance is one of the factors that will keep you taking one step forward and two steps back.

The solution is to get apologetically clear about what you want after spending time with the Lord. Get it out of your mind and written down on paper where you can see it. Yes, fears will come as you move towards your goal. Don't let them stop you; don't let them change your mind or cause you to waver. Move confidently towards your goal knowing that, as you do, God will go before you and clear the path for your success (Deuteronomy 31:8).

Reflect

Step 1: Pause. Think about what you really want to look like without censoring your thoughts. If you were not afraid of judgment, failure or deprivation, how would that change your goal? Notice your double-mindedness and identify the root of it. Take a few minutes and journal your thoughts.

Step 2: Pray. Review the scriptures that you've been studying over the last seven days. Can you apply those scriptures to your double-mindedness? Do you need to select a new scripture?

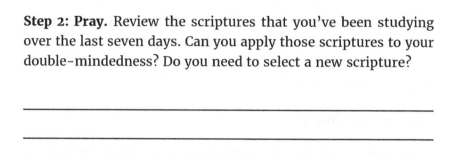

Step 3: Active Practice. As you go about your day, be sure to do your active practice. The more you can do it, the more successful you will become at eliminating your toxic thoughts. Is there a specific active practice you will do for this new toxic thought? If not, continue in the active practice that you've been doing for the last four days. Record it on your Active Practice Tracker and track how many times you performed it.

Prayer

"Good morning, Father. In Jesus' sweet Name, I come to You this morning in all of my humanness. I thank You for loving me exactly this way, in this state, on this day. I can actually feel Your love when You hug me, and I love You! I confess to You, Lord, that sometimes my loyalties are divided. My focus is split, distractions come along, and my attention gets diverted from the goal. And sometimes, my goal is something I've created and left You out of entirely. Please forgive me. This morning, reveal to me a clear vision of what You want for my life and help me set my mind and keep it set on that goal. Keep teaching me, Lord, not to waver with the fears that come up as I approach it, but to stay steady, trusting in Your power and goodness. Deliver me, please, from the double-mindedness that causes me so much anxiety. I want to feel the peaceful ease in my mind and body that comes as a result of the alignment of my thoughts with

Your will! Thank You for blessing me with a sound mind; please help me use it to stay laser-focused on the one thing that really matters — You! I declare today that I have the mind of Christ! In Jesus' Name. Amen."

What To Do Today

- Start your morning with a glass of lemon or ACV (apple cider vinegar) water.
- How many times did you complete your active practice today?
- Have you identified your double-mindedness? What is at the root of it?
- Track your active practice today.
- Drink seven to eight cups of water.
- Get a good night's sleep (at least seven hours).
- Can you begin to carve out some time for light exercise?

Planning for Tomorrow

- Have you begun to prepare your meals for next week? What will you be eating?
- Review the eating guide. Do you have all of the foods you need?
- Do you know exactly what you will be eating tomorrow?

Additional Scriptures

"We are destroying speculations and every lofty thing raised up against the knowledge of God, and we are taking every thought captive to the obedience of Christ."
2 Corinthians 10:5 (NASB1995)

"No one can serve two masters, for either he will hate the one and love the other, or he will be devoted to the one and despise the other. You cannot serve God and money."
Matthew 6:24 (NIV)

"Draw near to God, and he will draw near to you. Cleanse your hands, you sinners, and purify your hearts, you double-minded." James 4:8 (ESV)

Day 6: Fix Your Focus

Scripture Reflection

"... knew you not that I must be about my Father's business?"
Luke 2:49(ASV)

There's a principle that states that what you focus on expands. Imagine if you were to apply this principle to what you're currently doing. Based on this theory, you would end up eating more sugar and probably weighing more! Isn't that what happens to you? You focus on what you don't want, which just keeps giving you more of the same.

Despite all of the crazy diets and gimmicks, you often end up right back in the same place or even worse off than you started!

Here's a radical thought: What if you stopped focusing so much on your weight? What if you focused on being healthy and whole; on living out your life's purpose; on being a light wherever you go? Focus on living a life that reflects your love for God and His love for you. When you choose to focus your life on Christ, He will do magnificent things in you today.

Follow the path of focus Jesus laid out for you as you choose to be about our Father's business.

Reflect

Step 1: Pause. Where is your focus on your weight loss journey? Are you focused on your weight or on the cross? Be honest. Capture every thought and journal it.

Step 2: Pray. If your thoughts are more focused on weight loss, instead repent and renew your mind. Choose a scripture that will redirect your thoughts to Christ and away from yourself. This may be your current scripture, or you may need to select a new one.

Step 3: Active Practice. As you go about your day, be sure to do your active practice. The more you can do it, the more successful you will become at eliminating your toxic thoughts. Is there a specific active practice you will do for this new toxic thought? If not, continue in the active practice that you've been doing for the last five days. Record it on your Active Practice Tracker and track how many times you performed it.

Prayer

"Dear Lord, good morning. Thank You for being my good, good Father! As Your child, it's my heart's desire to be about Your business. Lord, I want to be in the business of love with You!! You know my heart and You know that sometimes I lose my focus and I pray for Your forgiveness. The ways of the world can get me deep into pride, focused on me — on my problems, what I look like, what people think of me, how much I weigh, what size clothes fit my body. Lord, when this happens, first help me feel Your grace. Then, please call my attention to it so that I can speak against these lies that say it's all about me. I am not

my own. This body is Your temple and You paid for it with Your precious blood. I want to honor You by caring for it exquisitely—by feeding it nourishing fuel, exercising it faithfully, and by getting enough rest. My earnest desire is to magnify You, sweet Jesus, not me or my problems! Give me the awareness and discipline to guard my heart and mind against magnifying the wrong things. Untangle this web of lies in my mind, Lord! I put on my helmet of salvation today, which protects my sanity, and keeps my focus on being about Your business of love! In Jesus' Name. Amen!"

What To Do Today

- Start your morning with a glass of lemon or ACV water.
- How many times did you complete your active practice today?
- Ask yourself what the real focus of this detox is. Can you make the Lord your focus?
- Track your active practice today.
- Drink seven to eight cups of water.
- Get a good night's sleep (at least seven hours).
- Can you begin to carve out some time for light exercise?

Planning for Tomorrow

- Have you begun to prepare your meals for next week? What will you be eating?
- Review the eating guide
- Do you have all of the foods you need?
- Do you know exactly what you will be eating tomorrow?

Additional Scriptures

"But seek first his kingdom and his righteousness, and all these things will be given to you as well."
Matthew 6:33 (NIV)

"We do this by keeping our eyes on Jesus, the champion who initiates and perfects our faith. Because of the joy awaiting him, he endured the cross, disregarding its shame. Now he is seated in the place of honor beside God's throne."
Hebrews 12:2 (NLT)

"Draw near to God, and he will draw near to you. Cleanse your hands, you sinners, and purify your hearts, you double-minded." James 4:8 (ESV)

Day 7: Week 1 Summary

Scripture Reflection

"Give thanks to the LORD, for he is good; his love endures forever." Psalms 107:1(NIV)

Congratulations on completing your first official week of Spirit-filled and Sugar Free!

I pray that you're starting to experience the benefits of living Spirit-filled and Sugar Free. Take some time to reflect on the past week.

1. Recap

Review the first week of your detox and devotions, and journal any new insights that you've learned. What are you discovering about yourself?

2. Reflect

Journal what Holy Spirit is showing you so far.

3. Pray

Commit your week to the Lord. Rest in Him and commit your heart to Him.

4. Plan

Have you planned out your week? What adjustments do you
need to make to your meal plan or your mindset?

Day 8: Live in the Solution

Scripture Reflection

"Do not be anxious about anything, but in everything by prayer and supplication with thanksgiving let your requests be made known to God." Philippians 4:6(ESV)

WORRY is what you do when you think about your problems all day long. You research them, tell everyone you know about them, replay them over and over in your mind, and find it difficult to see past the issue. This is what's called living in the problem. It's how most people live the greater part of their lives.

When you live problem-focused, you say things like: "Why is this happening to me?" "I can't do this," and, "It will never work." Problem-focused people are always waiting for the next thing to fix them or someone to come and rescue them from their current situation. If you're problem-focused, you may be feeling discouraged, trying to figure out how to get back on track, and wondering why this isn't working for you or worrying about what tomorrow is going to be like.

PRAYER is what you do when you think about God's Word over and over. It is how you live in the solution.

When you live in the solution and a problem arises, you say things like: "Lord, what are You trying to show me in this situation?" "How will this situation bring You glory?" "I take full responsibility for my actions."

Solution-focused people see problems as opportunities for growth, setbacks as setups for a comeback, tragedies as opportunities to triumph, and struggles as opportunities to be strengthened in the Lord.

To live a life of prayer, as you wake up give God thanks for the day and turn this detox over to Him. As you move throughout your day, give Him thanks for His Spirit living in you and whisper-breathe prayers to Him all day long. Before you eat a meal, give Him thanks and pray for the spirit of self-control and contentment. And as you end your day, give Him thanks and praise. If you broke your boundaries that day, repent and thank Him for His grace and mercy. Wake up the next day and repeat.

That, my friend, is how you live in the solution.

Reflect

Step 1: Pause. Do you confront challenges with worry or prayer? Your approach will determine if you live in the problem or the solution. Take some time and journal your thoughts.

Step 2: Pray. Review the scriptures that you've been studying over the last week. Use your scriptures to change your worries to prayers.

Step 3: Active Practice. As you go about your day, be sure to do your active practice. The more you can do it, the more successful you will become at eliminating your toxic thoughts. Is there a specific active practice you will do for this new toxic thought?

If not, continue in the active practice that you've been doing for the last nine days. Record it on your Active Practice Tracker and track how many times you performed it.

Prayer

"Hello, Jesus. Thank You for one more day with You! Today, I choose to live in the solution! Lord, I desperately need Your help with this. I've tried to change the old programming lingering around in my mind in my own strength — it's not enough, and I need You! I acknowledge that pathways have been worn into the nervous system that made worry a knee-jerk reaction to my life and created an atmosphere of anxiety in me. I repent right now of these habits and of the ways I've aligned my life with them. I'm magnifying the problems of the world rather than Your supernatural power, and it's kept me stuck in the problem. I declare right now that I agree with Your Word that You have overcome the world!!

Please help me to cease striving and to surrender completely to You, and to be patient as You transform me at Your perfect pace. Reset my mind, change my brain, pave new pathways that keep directing me to Your Word. Lead and guide me to walk alongside You and draw me even closer to You, Lord Jesus. Take my hand as I put down my worry bags (go ahead and name your bags as you hand them over, if you like). Thank You for so kindly carrying them for me so that I can be free in You! Amen."

What To Do Today

- Start your morning with a glass of lemon or ACV (apple cider vinegar) water.
- How many times did you complete your active practice today?
- Notice if much of your day is spent worrying or in prayer.

- Drink seven to eight cups of water and sip herbal teas throughout the day.

- Get a good night's sleep (at least seven hours).

- Can you begin to carve out some time for light exercise?

- Get some fresh air!

Planning for Tomorrow

- Review the eating guide. Do you have all of the foods you need?

- Do you know exactly what you will be eating tomorrow?

Additional Scriptures

"Therefore I tell you, whatever you ask in prayer, believe that you have received it, and it will be yours." Mark 11:24 (ESV)

"And I tell you, ask, and it will be given to you; seek, and you will find; knock, and it will be opened to you."
Luke 11:9 (ESV)

"Praying at all times in the Spirit, with all prayer and supplication. To that end keep alert with all perseverance, making supplication for all the saints." Ephesians 6:18 (ESV)

Day 9: Transformation

"I appeal to you, therefore, brothers, by the mercies of God, to present your bodies as a living sacrifice, holy and acceptable to God, which is your spiritual worship." Romans 12:1(ESV)

The heart of God is for continual transformation. He longs that you would be in constant union with Holy Spirit to lead you from moment to moment and continually transform you into His likeness.

There is much you can learn about your own transformation. The development of a butterfly from an egg to a beautiful mature butterfly is called metamorphosis. This is a Greek word that means transformation or change in shape.

During the butterfly's transformation, there's a very important stage called the pupa during with the caterpillar (chrysalis) is protected inside a cocoon of silk. This stage can last a few weeks, a month, or even longer. Some species have a pupal stage that lasts for two years. On the outside it may look like nothing is going on, but big changes are happening inside.

Doesn't this resemble your health journey, and even your Christian walk for that matter? It's a process — sometimes very long. And sometimes it feels like nothing's happening. But rest assured that you are protected as long as you trust the process.

You're constantly searching for the right thing that will fix you and make your life better, or for ways to speed up the process. You see transformation as an event or an encounter that suddenly changes your life. But in most instances, that is not how God works. Like the butterfly, God wants to transform your

life little by little, day by day as you draw close to Him. How do you do this? Each and every day, you present your body as a living sacrifice; you see everything you do as a form of worship to Him and show gratitude for the mercy that He has shown you. That's His plan for your metamorphosis.

Here's the beautiful thing about transformation. It's permanent! A butterfly can't revert into a caterpillar, so stop worrying about reverting to your old ways and trust the process. There's no going back. Believe that you have been transformed. Offer up your body as a living sacrifice to God each day and watch the transformation. He is faithful.

Reflect

Step 1: Pause. Check in. How do you/can you offer yourself as a living sacrifice each day? Take a few minutes and journal your thoughts.

Step 2: Pray. As you reflect on that thought, use your scripture/ declaration or confession to cancel it.

Step 3: Active Practice. As you go about your day, be sure to do your active practice. The more you can do it, the more successful you will become at eliminating your toxic thoughts. Is there a specific active practice you will do for this new toxic thought? If not, continue in the active practice that you've been doing for the last ten days. Record it on your Active Practice Tracker and track how many times you performed it.

Prayer

"Dear Glorious God, thank You for Your perfect plan for my transformation! Thank You so much that Your grace is sufficient for me and that I do not need to do the work of changing myself. In fact, Lord, I submit my efforts to be in charge of my transformation, and I recognize that I am simply not that powerful! I confess that only You possess the power to change hearts and transform lives! Lord, I don't want to stay the way I am. I want to grow. And I pretty much want results yesterday.

Forgive me for trying to rush this process and to push my agenda on Your perfect timeline. Help me first accept that this is a process (and not a singular event), and also to joyfully come to terms with exactly where You have me at this very moment. It feels uncomfortable to feel like I'm on the operating table, Lord, with You cutting away the parts that aren't needed and cleansing and healing old wounds. But I'm choosing to trust that I'm right in the palm of Your hand as I'm being transformed. Today, I present to You my body as a living and holy sacrifice and I choose to worship You every chance I get. In the precious Name of Jesus, Amen."

What To Do Today

- Start your morning with a glass of lemon or ACV water.
- Track your active practice today.

- Drink seven to eight cups of water and/or herbal tea.
- Get a good night's sleep (at least seven hours).
- Can you begin to carve out some time for light exercise?

Planning for Tomorrow

- Review the eating guide
- Do you have all of the foods you need?
- Do you know exactly what you will be eating tomorrow?

Additional Scriptures

"Therefore, if anyone is in Christ, he is a new creation. The old has passed away; behold, the new has come."
2 Corinthians 5:17 (ESV)

"I have been crucified with Christ. It is no longer I who live, but Christ who lives in me. And the life I now live in the flesh I live by faith in the Son of God, who loved me and gave himself for me." Galatians 2:20 (ESV)

"Create in me a clean heart, O God, and renew a right spirit within me. Cast me not away from your presence, and take not your Holy Spirit from me. Restore to me the joy of your salvation, and uphold me with a willing spirit."
Psalms 51:10–12 (ESV)

Day 10: Overcoming Complacency

Scripture Reference

"So here's what I want you to do, God helping you: Take your everyday, ordinary life — your sleeping, eating, going-to-work, and walking-around life — and place it before God as an offering. Embracing what God does for you is the best thing you can do for him. Don't become so well-adjusted to your culture that you fit into it without even thinking. Instead, fix your attention on God." Romans 12:1-2a (MSG)

How many times have you cut out sugar, only to go back to your old familiar habit and patterns?

Because of God's incredible love for you, He does not want you to remain stuck or stagnant in any area of your life. His plan is for you to see His glory manifested in each and every area of your life.

Yet despite God's plan for you, you may still struggle with complacency. Whether it's due to poor habits, not being surrounded by good role models, loss of hope, settling for low standards or poor self-esteem, complacency is a stronghold to be uprooted from your life.

Paul tells the Philippians (Phil 3:12) that he has learned the secret to overcoming complacency. Paul's secret is that he is always striving to do what God has called him to do. He is not focused on his needs, his wants, his desires, or his agenda. At the end of the day, Paul did his best to be faithful to God's call on his life. He states, *"I press on to take hold of that for which Christ*

Jesus took hold of me — I press on toward the goal to win the prize for which God has called me heavenward in Christ Jesus."

If you want to avoid becoming complacent, either on this health journey or in any other areas of your life, take your everyday ordinary life and offer it as a sacrifice to God. Take this 30-day detox, every meal you eat, every workout you do, every situation you encounter, and place it before God as an offering. Refuse to grow complacent with where you are in life. Rather, work diligently to glorify God in everything you do.

As you go about your day, think about offering everything up to God. Let your goal be to bring honor to Him in everything you do. Imagine how your life would be transformed! Imagine how your heart would be full of gratitude. This, my friend, is the cure for overcoming complacency.

Reflect

Step 1: Pause. Think about how you grow complacent as you try to give up sugar and/or on your weight-loss journey. Now think about how different your daily life would be if you offered up everything you did to God. Capture your thoughts as you meditate on this scripture.

Step 2: Pray. As you reflect on how you grow complacent on your weight-loss journey, what scriptures will be helpful during times of complacency?

Step 3: Active Practice. As you go about your day, be sure to complete your active practice. The more you can do it, the more successful you will become at eliminating your toxic thoughts. Is there a specific active practice you will do for this new toxic thought? If not, continue in the active practice that you've been doing. Record them on your Active Practice Tracker and track how many times you performed it.

Prayer

"Heavenly Father, thank You for another day of living with the privilege to grow into the person You made me to be! My desire is to give it all to You in thanks for all the ways You love me, and for the ultimate sacrifice You paid for me. Lord, help me to be conscious of how I live and don't allow me to fall into fitting into worldly ways of doing or being. It's so easy to compromise and to grow content with the cultural status quo. But that's not what You're calling me to, so I renounce the ways I've allowed myself to slip into worldly patterns. I repent. My Lord, may I walk in Your Spirit, offering each simple act as a living and holy sacrifice to You. Slow me down and show me that the little things matter.

Help me to learn to wear life like a loose-fitting garment; also to take to heart the great love You have for me. I want a life that reflects those things, one that shows off Your heart and Your character to the world — that it (and I) may slowly, but surely, conform to Your ways. Today, Lord, I reject the spirit of complacency and I press on toward the goal to win the prize that You've called me to in Christ! In His Name. Amen."

What To Do Today

- Start your morning with a glass of lemon or ACV/water.
- Track your active practice today.
- Drink seven to eight cups of water and/or herbal tea.
- Get a good night's sleep (at least seven hours).
- Can you begin to carve out some time for light exercise?

Planning for Tomorrow

- Review the eating guide. Do you have all of the foods you need?
- Do you know exactly what you will be eating tomorrow?

Additional Scriptures

"For the simple are killed by their turning away, and the complacency of fools destroys them." Proverbs 1:32(ESV)

"'I know your works: you are neither cold nor hot. Would that you were either cold or hot! So, because you are lukewarm, and neither hot nor cold, I will spit you out of my mouth." Revelation 3:15-16(ESV)

"Do you not know that in a race all the runners run, but only one receives the prize? So run that you may obtain it. Every athlete exercises self-control in all things. They do it to receive a perishable wreath, but we an imperishable. So I do not run aimlessly; I do not box as one beating the air. But I discipline my body and keep it under control, lest after preaching to others I myself should be disqualified."
1 Corinthians 9:24-27(ESV)

Day 11: Eliminate Hurry, Eliminate Worry

Scripture Reflection

"Martha, Martha," the Lord answered, "you are worried and upset about many things, but few things are needed—or indeed only one. Mary has chosen what is better, and it will not be taken away from her." Luke 11:41-42 (NIV)

You may turn to sugar because it's quick and easy. It provides you with a quick boost of energy which is just what you need when you're rushing from one thing to the next. Unfortunately, like with any drug, you quickly get addicted and end up craving more and more. Instead of always trying to kick sugar out of your life, learn to eliminate your hurry and fast-paced lifestyle.

Famous Christian author Dallas Willard said, "Hurry is the great enemy of spiritual life in your day. It is essential to ruthlessly eliminate hurry from your life."

Luke 11:41 reminds us what's important. It reminds you to model the pace of your life after Jesus. He was never in a hurry. If Jesus, who had the most important ministry in all of history, saw it as important to slow down and reflect, how much more should you follow His example?

No doubt Martha was very responsible. She got things done! She handled her business. You feel so stressed and out of control that, like Martha, sometimes you snap and lose your cool. "Lord, don't you care?" (Luke 10:40). You grow resentful that your husband or neighbor is able to rest and enjoy life while you're stuck doing all the work. Oh, the injustice! The drama!

Yet the Lord continually teaches us, like He taught Martha, the solution to eliminate worry and hurry. He assures her that Mary's choice to rest at His feet was the right thing to do. He offers you the same invitation. In fact, He reminds her that it's the only way; the better way. Choose to make time to linger at the moment, to savor the stillness of the present, or to just be.

Don't allow the tendency of doing more take priority over making time to rest at the feet of Jesus. You don't need to feel you have to do it all, like Martha. Like Mary, let Jesus be your all!

Reflect

Step 1: Pause. Are you often in a rush? Why do you feel you need to do things in a hurry? Capture your thoughts as you turn your hurry and worry over to God.

Step 2: Pray. As you reflect on that thought, use your scripture/ declaration or confession to cancel it.

Step 3: Active Practice. As you go about your day, be sure to do your active practice. The more you can do it, the more successful you will become at eliminating your toxic thoughts. Is there a specific active practice you will do for this new toxic thought? If not, continue in the active practice that you've been doing. Record it on your Active Practice Tracker and track how many times you performed it.

If hurry and worry produce your greatest toxic thoughts, consider visualizing yourself sitting at the feet of Jesus.

Prayer

"Dear Lord Jesus, thank You for a brand new day. Thank You so much for the invitation to rest and sit at your feet. The pressure to "do" in this world can feel unbearable at times, Lord. And I'm sorry that sometimes I find myself thinking I'm too busy for You. I can hear how crazy that sounds now, but at the moment I confess I've done it. Please help me to reorder my priorities, putting You first, and allow You to take over my heart! Help me to truly experience Your Presence by allowing the other things that compete for my affection to fall away.

Bring the peace that passes all understanding into the center of me, so that when thoughts surface and waves of emotion flow I don't panic to change them. Holy Spirit, teach me how to simply connect with You, just the way that I am, without worry or hurry. Even when Martha was uptight and upset, You spoke so affectionately to her and redirected her attention — what a kind, loving, and gentle God You are! How I cherish Your brand new mercies this morning and now I accept Your sweet invitation to just sit with You, my Lord. In the holy Name of Jesus Christ. Amen."

What To Do Today

- Start your morning with a glass of lemon or ACV water.
- Track your active practice today.
- Drink seven to eight cups of water and/or herbal tea.
- Get a good night's sleep (at least seven hours).
- Can you begin to carve out some time for light exercise?

Planning for Tomorrow

- Review the eating guide.
- Do you have all of the foods you need?
- Do you know exactly what you will be eating tomorrow?

Additional Scriptures

"But the fruit of the Spirit is love, joy, peace, patience, kindness, goodness, faithfulness, gentleness, self-control; against such things there is no law." Galatians 5:23-24 (ESV)

"The Lord is not slow to fulfill his promise as some count slowness, but is patient toward you, not wishing that any should perish, but that all should reach repentance." 2 Peter 3:9 (ESV)

Day 12: Good Roots, Good Fruits

Scripture Reflection

"And He spake many things unto them in parables, saying, Behold, a sower went forth to sow; and when he sowed, some seeds fell by the wayside, and the fowls came and devoured them up: some fell upon stony places, where they had not much earth: and forthwith they sprung up, because they had no deepness of earth: and when the sun was up, they were scorched; and because they had no root, they withered away. And some fell among thorns; and the thorns sprung up, and choked them: but other fell into good ground, and brought forth fruit, some a hundredfold, some sixtyfold, some thirtyfold." Matthew 13:3-8 (KJV)

Overcoming sugar addiction is not something that you can do in your own strength. That's why you need the fruits of the Spirit, such as patience and self-control, that can help you kick your sugar habit once and for all.

Through the power of the Holy Spirit, you are able to bear the incredible fruit of abundant life. This truth should fill you with tremendous hope. Fruits such as love, joy, peace, patience, kindness, goodness, faithfulness, gentleness, and self-control (Galatians 5:22-23) are your inheritance, and are an outward showing of your spiritual growth and maturity.

Sadly, it may be that you have stunted your growth. Instead of bearing the fruits of the Spirit, when you look at yourself you see pride, laziness, guilt, impatience, selfishness, harshness, and lack of self-control. It's time to change this perception of yourself. God's fruits are in you, waiting to be manifested.

The verses in Matthew 13:3-8 gives us a very vivid picture of how you can manifest the fruits of the Spirit that you desperately seek. Jesus teaches the disciples how to bear good fruits. He teaches us that the power is in the depth of the roots, which is analogous to God's Spirit guiding and working in you. Notice that a plant with shallow roots will wither away. He also teaches the disciples (and you) that:

- If you are not rooted in Christ, it's easy for you to hear the Word of God with no real intention of obeying it. So lean in to hear the Word and then obey.

- Without spiritual roots, trials and resistance will quickly pull you back into the world. Deep roots will keep you anchored and grounded.

- To bear good fruit, a plant (you) must be in good soil which can yield, "some a hundredfold, some sixty, some thirty."

Bearing good fruit is not something you develop in your own strength, but is a natural result of being grounded in the love of God. May your roots be strong and deep. Let's endeavor to make Psalms 1:1-3 (NIV) your life goal:

> *"Blessed is the one who does not walk in step with the wicked or stand in the way that sinners take or sit in the company of mockers, but whose delight is in the law of the Lord, and who meditates on his law day and night. That person is like a tree planted by streams of water, which yields its fruit in season and whose leaf does not wither—whatever they do prospers."*

Reflect

Step 1: Pause. How do you feel about the fruits you are manifesting? How can you strengthen/deepen your roots? Study what this scripture says about roots and fruits.

Step 2: Pray. What toxic thoughts spring up when you think about the fruit you produce? Use Scripture to replace your negative thoughts about the fruit you produce. Read Galatians 5:22–23.

Step 3: Active Practice. As you go about your day, be sure to complete your active practice. The more you can do it, the more successful you will become at eliminating your toxic thoughts. Is there a specific active practice you will do for this new toxic thought? If not, continue in the active practice that you've been doing. Record it on your Active Practice Tracker and track how many times you performed it.

Prayer

"Dear Master Gardener, good morning! Thank You for being the Master Sower. And for the gift of Your Word which will endure

forever. It's easy for me to see myself and my life with earthly eyes, to see my spiritual immaturity, to focus on my flaws and the ways I fall short, and to be concerned with judgment. Lord, I confess my pride and turn to You to receive the glorious gift of Your forgiveness! Thank You! The truth is that I want to bear good fruit, and in doing so I truly want to glorify You! Today I ask You to ground me and root me in Your love. Let me steep in the truth of Your Word so that the weeds in me no longer survive. Till the soil in my mind, Master Gardener; make it a fertile place to receive the seeds of those good fruits You've sown in me. Sink my roots deep into Your love so that I thrive! Change my focus, Lord, and let me see myself and others through Your eyes — one who is growing and maturing at Your perfect pace and one who already possesses all she needs in You to bear good fruit, a hundredfold what You planted! In Jesus' awesome Name. Amen."

What To Do Today

- Start your morning with a glass of lemon or ACV water.
- Track your active practice today.
- Drink seven to eight cups of water and/or herbal tea.
- Get a good night's sleep (at least seven hours).
- Can you begin to carve out some time for light exercise?

Planning for Tomorrow

- Review the eating guide.
- Do you have all of the foods you need?
- Do you know exactly what you will be eating tomorrow?

Additional Scriptures

"A good tree cannot bear bad fruit, nor can a bad tree bear good fruit. Every tree that does not bear good fruit is cut down and thrown into the fire. Therefore by their fruits you will know them." Matthew 7:18–20 (NKJV)

"That person is like a tree planted by streams of water, which yields its fruit in season and whose leaf does not wither— whatever they do prospers." Psalms 1:3 (NIV)

"He will be like a tree planted by the waters that sends out its roots toward the stream. It does not fear when the heat comes, and its leaves are always green. It will not worry in a year of drought or cease producing fruit." Jeremiah 17:8 (NIV)

Day 13: Discipline – Pain or Pleasure

Scripture Reflection

"No discipline seems pleasant at the time, but painful. Later on, however, it produces a harvest of righteousness and peace for those who have been trained by it." Hebrews 12:11 (NIV)

Let's be honest. It takes incredible discipline to prepare sugar free foods. It takes discipline to pause before inhaling your food. And it takes discipline to stop eating something that tastes so good. Some people are naturally more disciplined than others. It could be their natural personality, their upbringing, their ability to forgo gratification, or a deep sense of understanding that short-term discomfort is better than long-term regret.

Regardless of where you fall on the spectrum of discipline, Hebrews 12:11 teaches us an important principle about discipline. The principle is that in order for you to benefit from God's discipline, you must be "trained" by it. This training is necessary for God to strengthen your spiritual muscles. If you try to bypass or forego the pain of training, you will pay for it later by being defeated by temptation and sin. You will continually feel in bondage if you keep satisfying your flesh by enjoying the immediate pleasure, instead of 'suffering' through the temporary pain. You can't have both.

So just how do you learn discipline? The key is not in yourself, but upward. Discipline is a gift you receive from Holy Spirit. It is not something you can muster up in your own strength. However, Hebrews 12:11 also teaches us that you have a responsibility to accept the training.

Ultimately, self-discipline is about accepting Christ's discipline. It requires you to continually train yourself to bring your flesh and your desires under the control of Christ by the power of His Spirit. Yes, it is not pleasant at the time, but continually train yourself to look beyond the immediate pain. God would never command you to do something and make it too difficult (Deut. 30:11). There is much pleasure for you to experience at the end of the journey if you accept God's training. It's worth it! You're worth it!

Reflect

Step 1: Pause. What thoughts come to mind when you think about discipline? Does it help to think of the long-term benefit?

Step 2: Pray. What toxic thoughts spring up when you think about discipline? Use Scripture to replace your negative thoughts about the discipline you produce.

Step 3: Active Practice. As you go about your day, be sure to do your active practice. The more you can do it, the more successful you will become at eliminating your toxic thoughts. Is there a specific active practice you will do for this new toxic thought?

If not, continue in the active practice that you've been doing. Record it on your Active Practice Tracker and track how many times you performed it.

Prayer

"Dear Lord, thank You that You love me enough to want to discipline me! Your desire to shape and mold me comes from Your deep Fatherly love and affection for me, which I'm so grateful for. I will admit it doesn't always feel comfortable in the moment — almost never, actually. But I'm growing in my understanding as I get to know You more intimately as my good Father. Today I ask You to please give me a fresh revelation of Your love for me and a picture of how Your will for me will actually lead me to the best possible outcome. Give me the patience to tolerate the momentary discomfort of going without and turn what seems like deprivation into a keen sense of expectation — an expectation of the wonderful blessings You wish to bestow upon me as I grow in maturity in You. Father, please continue to keep my focus on You rather than on me, so that I may see that Your goal is to have Your glory shine in the world. And it does that best when Your kids look like You. I need Your discipline if I'm going to shine for You, Lord! Thank You, sweet Lord Jesus, for the seed of self-control You put in me and the love You show me through teaching me discipline! In Jesus' Name. Amen."

What To Do Today

- Start your morning with a glass of lemon or ACV water.
- Track your active practice today.
- Drink seven to eight cups of water and/or herbal tea.
- Get a good night's sleep (at least seven hours).

- Can you begin to carve out some time for light exercise?

Planning for Tomorrow

- Review the eating guide.
- Do you have all of the foods you need?
- Do you know exactly what you will be eating tomorrow?

Additional Scriptures

> *"The LORD hath chastened me sore: but he hath not given me over unto death."* Psalms 118:18 (NIV)

> *"Correction is grievous unto him that forsaketh the way: and he that hateth reproof shall die."* Proverbs 15:10 (KJB)

Day 14: Week 2 Summary

Scripture Reflection

"Give thanks to the LORD, for he is good; his love endures forever." Psalms 107:1(NIV)

Congratulations on completing your second week of Spirit-filled and Sugar-free. One more week to go!

As you wrap up this week, begin to think about what life will be like for you after the 30-day detox is over.

1. Recap

Review this past week of devotions and your success with the sugar detox, and journal any new insights that you've learned. What challenges and successes did you experience this week?

2. Reflect

Journal what Holy Spirit is showing you so far. How will this detox positively impact your life?

3. Pray

Commit your week to the Lord. Rest in Him and commit your heart to Him.

4. Plan

Have you planned out your week? Do you have the foods that you need to be successful?

Day 15: Fix Your Focus

Scripture Reflection

"Set your mind and keep focused habitually on the things above [the heavenly things], not on things that are on the earth [which have only temporal value]."
Colossians 3:2 (AMP)

The discipline of fixing your focus on God is the simplest secret to living a successful life, yet it's one of the most challenging things to do.

Over and over in the Bible, you're encouraged to fix your eyes upwards and not on yourself.

"Set your mind and keep focused habitually on the things above [the heavenly things], not on things that are on the earth [which have only temporal value]." Colossians 3:2 (AMP)

"Fixing our eyes on Jesus, the author and perfecter of faith." Hebrews 12:2a (NASB)

"Fix [your] eyes not on what is seen, but on what is unseen. For what is seen is temporary, but what is unseen is eternal." 2 Corinthians 4:18 (NIV)

Yet your patterns are more like Peter when he attempted to walk on water. He started off great. He was focused. He was doing it! That successful start should have been enough to strengthen his confidence so he could complete the task. But like you, as soon as the seas start raging; as soon as the sugar craving hits; as soon as your emotions are triggered; as soon as you look at how far you still need to go instead of how far you've come; as soon as you remember your past, you sink.

How can you avoid this continual sinking? What if you started simply being more honest with God and with yourself? What if you just started where you are at this present moment? Are you meeting with a friend today? Invite God to be with you. Have you broken your sugar boundaries? Ask God to help you. Having a lazy day on the couch? Invite God there — no judgment, no condemnation. Do you want to eat outside of your boundaries? Just acknowledge His presence in the midst of it. He's already there, so all you're doing is acknowledging His presence. You come out of His presence because you fear His judgment, which is your own judgment of yourself. Sometimes you don't fix your eyes (mind) on Christ because you don't want Him to see you in your current state, but all He asks for is your honesty.

Habitually fix your focus on His Presence regardless of what you are or are not doing right, and you will begin to experience Him as a friend and not as a judgmental disciplinarian who is always mad at you. Go ahead, do it right now! Allow Him to flood your misconceptions with His relentless love and grace for you as you fix your eyes on Him.

Reflect

Step 1: Pause. What thoughts come to mind when you think about habitually fixing your mind on Christ? What stops you from doing this all the time? Capture your thoughts.

Step 2: Pray. What toxic thoughts spring up when you think about sharing all your life with Christ? Use Scripture to replace your negative thoughts and fears about the end of this program.

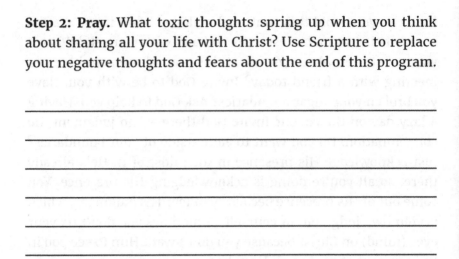

Step 3: Active Practice. As you go about your day, be sure to complete your active practice. The more you can do it, the more successful you will become at eliminating your toxic thoughts. Is there a specific active practice you will do for this new toxic thought? If not, continue in the active practice that you've been doing. Record it on your Active Practice Tracker worksheet and track how many times you performed it.

Prayer

"Dear Heavenly Father, good morning! Thank You, Lord, that I can never hide from You! It amazes me to consider how it could be possible that You're with me and each of Your children every single moment. I don't know how You do it, Lord, but I'm so grateful that You never leave me alone — EVER! I admit that sometimes I allow fear and shame to take me away from You, and these feelings can make me feel alone and isolated from You. It's then that I can forget about You so easily. I repent of this form of prideful self-focus that says what I think of me is more important than what You think, who You are, and what You've done for me. I'm so sorry, Lord! I stand up today and declare my humble gratitude for Your constant presence with

me. You sent Jesus to die on the cross so that You and I could be together forever, and I want that, too! I don't want to take that for granted anymore. Thank You that You've already reconciled my sinful self to You, almighty God!!! I can be imperfect and be loved by You — that's amazing!!! Holy Spirit, lead me away from the devil's schemes to keep me stuck on me, and please help me to come out of hiding and be real with You. I am no surprise to You. Please keep my focus on Your abundance rather than on my lack. Increase and I will decrease, and by Your Spirit this change of focus is happening in my heart and mind. I praise You each day for who You are and for all You've done for me. In Jesus' magnificent Name. Amen!"

What To Do Today

- Start your morning with a glass of lemon or ACV water.

- Practice praying whenever your mind wanders off or slips into negative thinking.

- Track your active practice today.

- Drink seven to eight cups of water and/or herbal tea.

- Get a good night's sleep (at least seven hours).

- Can you begin to carve out some time for light exercise?

Planning for Tomorrow

- Review the eating guide.

- Do you have all of the foods you need?

- Do you know exactly what you will be eating tomorrow?

Additional Scriptures

"Set your mind and keep focused habitually on the things above [the heavenly things], not on things that are on the earth [which have only temporal value]."
Colossians 3:2 (AMP)

"Fixing our eyes on Jesus, the author and perfecter of faith."
Hebrews 12:2a (NASB)

"Fix [your] eyes not on what is seen, but on what is unseen. For what is seen is temporary, but what is unseen is eternal."
2 Corinthians 4:18 (NIV)

Day 16: Progress, Not Perfection

Scripture Reflection

> *"Little by little I will drive them out before you, until you have increased enough to take possession of the land."*
> Exodus 23:30 (NIV)

God is not looking for perfection. He is looking for progress.

These same principles apply to detoxing from sugar. It will take time for you to keep sugar out of your body for God. Your success is based on consistent actions that draw you closer to God. The more you hunger for God, the more you starve your desire for the things that are not of God.

When You're Perfection-Driven

- You're constantly trying to do better.
- You want to quit when you mess up.
- You're often guilt-ridden.
- You often blame circumstances or people for why things are the way they are.
- You experience a lot of shame and anxiety.
- You are easily swayed, bored, or quick to give up and ready to try the next new thing.
- You're hyper-focused on the final goal and not on the steps along the way.
- You're constantly judging, evaluating, and berating yourself. You use words like, 'I've failed', 'I blew it',

'I screwed up again', 'I will never get there', 'I need to.'

- You constantly set goals that are impossible, unrealistic, non-specific, unattainable, and indefinite and noncommittal — I need to eat healthier, I need to start exercising, I've got to lose weight.

- You refuse to go deep and only look at surface causes so you may never get past dieting and exercising.

- You operate from a place of lack and not good enough.

- You constantly feel in bondage, frustrated.

- You're afraid that you will never reach your goal and fear that you will easily lose control.

- You use your past as a measuring stick for how well you will perform in the future.

- Changes are rarely permanent.

When You're Progress-Driven

- You realize that there will be seasons of high success and victory and seasons with not so much progress, and it's all good.

- You realize that it's a slow and steady journey and not a sprint.

- You understand that God is developing patience and perseverance in you and these qualities are developed over time.

- I read a great post that said, "One step backward after taking a step forward is a cha-cha and not a disaster". That's a great process-driven mindset!

- You realize that there is joy in the journey and it's not tied to your final goal.

- You set mini, achievable goals with clear timelines and actionable steps along the way.

- You understand that root causes are deeply entrenched patterns being uprooted before 'real' growth can take place.

- You operate from a place of abundance and prosperity.

- You trust God and trust yourself. You know that 'all things work together' and truly believe that God's got it.

- You don't feel fear or anxiety about failing, and know and believe that you will achieve your goal.

Reflect

Step 1: Pause. In the past, how were your attempts to release weight perfection-driven? How are you responding differently now, if at all? Capture your thoughts and journal them.

Step 2: Pray. What toxic thoughts spring up when you think about 'messing up' or feeling like you failed? Use Scripture to replace your negative thoughts about the process of weight release.

Step 3: Active Practice. As you go about your day, be sure to complete your active practice. Maybe apply a specific one when you get frustrated with the process. The more you can do it, the more successful you will become at eliminating your toxic thoughts. Is there a specific active practice you will do for this new toxic thought? If not, continue in the active practice that you've been doing. Record it on your Active Practice Tracker and track how many times you performed it.

Prayer

"Lord, I thank You so much that there is not one thing that I could do (or not do) to make You love me any more or any less than You do right now. I confess right here and now that You don't find me less perfect today than You would at a more ideal size or shape or weight. I apologize that I've, on some level, believed that Your love is fickle and shifty and based on my performance, God. Would You please forgive me for this attitude and heal my heart and mind? The truth is that Your love never changes, that it's unfailing, never-ending, and has not one thing to do with my perfection or lack thereof. Rather, it has everything to do with Jesus' perfection and with the righteousness that is mine only because of Him. Let this truth totally revitalize my life and transform my mind, Holy Spirit. I ask You to help me to see me as You see me, a perfectly loved, delightfully imperfect human created in Your image, who is being made more and more into the likeness of Christ each day. The Bible says I'm a work in progress and that You promise to finish the good work You began in me, so I choose to believe that today instead of the lie that perfection makes me better! Help me to rest in the knowledge that I don't have to be the best. You just want me to do my best to follow and connect with You each and every day. Remind me, Holy Spirit, that You are strong where I am weak and that I need not be ashamed of those places. I invite You in — especially into my weight-releasing journey — into the

places I've kept covered and hidden in shame. I renounce shame and perfectionism in Jesus' Name. I say yes to the progress that comes by letting You, the Potter, mold me into the likeness of the cross, day by day. Amen."

What To Do Today

- Start your morning with a glass of lemon or ACV water.
- Track your active practice today.
- Drink seven to eight cups of water and/or herbal tea.
- Get a good night's sleep (at least seven hours).
- Can you begin to carve out some time for light exercise?

Planning for Tomorrow

- Review the eating guide.
- Do you have all of the foods you need?
- Do you know exactly what you will be eating tomorrow?

Additional Scriptures

"Let us not become weary in doing good, for at the proper time we will reap a harvest if we do not give up."
Gal 6:9 (NIV)

"And we all, who with unveiled faces contemplate the Lord's glory, are being transformed into his image with ever-increasing glory, which comes from the Lord, who is the Spirit." 2 Cor. 3:18 (NIV)

"Catch for us the foxes, the little foxes that ruin the vineyards, our vineyards that are in bloom." Song of Solomon 2:15 (NIV)

Day 17: Gaining a Proper Perspective

Scripture Reflection

"We saw the Nephilim there (the descendants of Anak come from the Nephilim). We seemed like grasshoppers in our own eyes, and we looked the same to them." Number 13:33 (NIV)

Here's a powerful truth, that if properly grasped will transform your entire life:

> All of your actions, thoughts, feelings, and behaviors are based on your perception of yourself.

In practical terms, this means that if you don't believe that you will ever truly kick your sugar habit, then you're probably right.

You cannot out-perform, out-pray, out-exercise, or out-diet your perception of self. Like a homeless person winning the lottery, it's only a matter of time before a faulty perception of self will bring someone right back to their initial situation.

Like the scouts who went to survey the land with Caleb, your perceptions and emotions cause you to lose sight of God's promises. Your emotions in the heat of the moment cause you to choose worry over your weapons and fear over faith.

One of the worst effects sin has is distorting your perception of yourself in relation to God. The devil always tries to separate us from God. Jesus came to Earth to destroy the power of sin in your life. He came so you can have a healthy and wholesome relationship with your heavenly Father that is based on truth.

Caleb understood that he was the Lord's; he understood the purpose and plan God had for His people and for him as an individual. He knew that what God had called him to do, he could do in the Lord's strength alone. His confidence and strength was in the Lord, and he knew that it was the Lord who would give him the ability to overcome the land. He saw way beyond the physical circumstances.

The other men only looked at what they could see and understand. They believed that they were too weak and incapable of defeating the inhabitants of the land, which they were, but their fears inhibited their faith and trust in the Lord.

Caleb understood that his strength was in the Lord. The other men only saw themselves and what they could do, not what the Lord would do.

The great news is that self-perceptions can be changed. The same thoughts, habits, and mindsets that contributed to the excess weight can also be repurposed to change the way you see yourself. The truth that is hidden in God's Word is to challenge what you believe to be true. Replace your false beliefs with truths. Let go of what the world has led you to believe about yourself, and embrace God's truth of who you are in Him.

Reflect

Step 1: Pause. Reflect on your own perceptions. How do you view yourself? Do you believe that you are truly an overcomer? How do your perceptions keep you stuck? Capture your thoughts.

Step 2: Pray. What toxic thoughts spring up when you think about yourself and your ability to overcome your weight challenges? Use Scripture to replace your negative thoughts that spring up.

Step 3: Active Practice. As you go about your day, be sure to complete your active practice. Maybe apply a specific one when you have a negative thought about yourself. The more you can do it, the more successful you will become at eliminating your toxic thoughts.

Prayer

"Dear Lord, I speak Your truth into my life. When You say that I am fearfully and wonderfully made, I know You mean it! I release all faulty perceptions of myself and only claim who I am in You. Let Your thoughts be my thoughts. I focus on living in the image of who You created me to be and reject the enemy's lies that try to tell me that I am not who You say I am. I have Your mind, and it has transformed me! As I draw closer to You, I'm starting to see myself the way You see me — whole and complete, lacking nothing! As I continue to rehearse my new healthy perception, my nervous system is realigning with my perception, my mind is realigning with my new perception, and as a result my actions are coming in line with my new perception. What a blessing! I love how You're constantly changing me from the inside out. Like the beautiful butterfly that is transforming, I can't always see what's happening at the various stages of growth. In fact, sometimes it feels like nothing is happening.

During those times, help me to trust the process. I can see so much clearer now and I thank You for changing my perspective. Life is so much sweeter when I can see myself as You see me. In Jesus' Name. Amen."

What To Do Today

- Start your morning with a glass of lemon or ACV water.
- As you reflect on how you see yourself, pray, and use Scripture to renew your mind.
- Track your active practice today.
- Drink seven to eight cups of water and/or herbal tea.
- Get a good night's sleep (at least seven hours).
- Can you begin to carve out some time for light exercise?

Planning for Tomorrow

- Review the eating guide.
- Do you have all of the foods you need?
- Do you know exactly what you will be eating tomorrow?

Additional Scriptures

"Now I say that the heir, as long as he is a child, does not differ at all from a slave, though he is master of all, but is under guardians and stewards until the time appointed by the father. Even so we, when we were children, were in bondage under the elements of the world. But when the fullness of the time had come, God sent forth His Son, born of a woman, born under the law, to redeem those who were under the law, that we might receive the adoption as sons. And because you are sons, God has sent forth the Spirit of His

Son into your hearts, crying out, 'Abba, Father!' Therefore you are no longer a slave but a son, and if a son, then an heir of God [through Christ." Galatians 4:1-7 (NKJV)

"Therefore, if anyone is in Christ, he is a new creation. The old has passed away; behold, the new has come."
2 Corinthians 5:17 (ESV)

"I praise you, for I am fearfully and wonderfully made. Wonderful are your works; my soul knows it very well."
Psalms 139:14 (ESV)

"I have been crucified with Christ. It is no longer I who live, but Christ who lives in me. And the life I now live in the flesh I live by faith in the Son of God, who loved me and gave himself for me." Galatians 2:20 (ESV)

Day 18: Why This, Why Me, Why Now?

Scripture Reflection

"Beloved, do not be surprised at the fiery trial when it comes upon you to test you, as though something strange were happening to you. But rejoice insofar as you share Christ's sufferings, that you may also rejoice and be glad when his glory is revealed." 1 Peter 4:12-13 (ESV)

If you've been battling sugar for most of your life, then you understand the mental and emotional pain. No, it's not like physical pain of a broken limb, but it's pain nevertheless.

Nothing tests your faith like pain. It could be physical pain, emotional pain, pain from the loss of a relationship, or pain of hopes and dreams not being realized. Whatever the pain, the one thing for sure is that it's unavoidable.

Because pain is...well...uh...painful, your natural reaction is to avoid it, to alleviate it, or to numb it. But what if you knew that your pain truly has a purpose, and it is necessary for your growth and success? Would you stop trying to avoid pain at all costs? Would you learn to accept that it's part of the journey? How would it cause you to act differently?

Because pain is so counterintuitive, let's see what you can learn from it:

PAIN TESTS YOU. In James 1:2-3, God promises you maturity and wholeness in Him as you endure the pain of trials and tribulations.

PAIN CORRECTS YOU. Whether it's physical, emotional, or spiritual pain, your response should be to use it as a signal that you need to change course. Are you willing to use it to change your course? What is your pain telling you that you need to correct? (Hebrews 12:11-21)

PAIN UNITES YOU. Pain gives you compassion for others who are hurting, and enables you to minister to them more effectively. Your pain gives people hope because they know that if you survived, they too can make it. (2 Corinthians 1:4-6)

PAIN DIRECTS YOU. There is a purpose in your pain and discomfort! Your pain is not in vain, my sister. Regardless of the source of your pain, God wants to use everything in your life to glorify Him. The pain will not go away until the reason for its arrival has been completed. Instead of asking God to remove the pain, ask Him what He's teaching you. Ask Him what He wants to do in your life as a result. (Proverbs 3:11-12)

PAIN PROTECTS YOU. If you've ever put your hand on a hot stove, you'll understand the benefits of pain. It teaches you what's dangerous and what you need to stay away from. (1 Corinthians 10:13)

PAIN STRENGTHENS YOU. Working out at the gym is painful. Without the physical pain, the microscopic tears in the muscle necessary to make the new muscle stronger will not take place. At the gym, muscle growth is developed by 'time under tension' — muscle tearing then healing. This is a great metaphor for your life. Physical (mental, emotional) pain will bring your strengths and your weaknesses to the surface. When you can turn to God during the painful aspects of your life, He will strengthen you. (James 1:12)

PAIN CONFORMS YOU. I wish I were as close to God when life is going smoothly as when I'm desperately clinging to Him in

times of pain and desperation. Pain draws you toward the only one who can bring you through these difficult times in your life. (Romans 8:28)

PAIN DEFINES YOU. Think of all the great leaders you know. What made them great leaders? Was it their success? Maybe, but more accurately it was probably their success in light of their adversity. The legacies of Mother Teresa, Corrie Ten Boom, Gandhi, Martin Luther King, and Nelson Mandela came about because of what they were willing to strive and struggle for. Their pain defined their lives — not as defeated men and women but as overcomers!!! What will your legacy be?

When you can find purpose in your pain...

- Your misery will become your ministry.
- Your problem will become your purpose.
- Your greatest pain will produce your greatest power.
- Your greatest struggles will become your successes.

Reflect

Step 1: Pause. What toxic thoughts come to mind when you think about the pain (anxiety) that often comes along with living sugar free? Journal it.

Step 2: Pray. Use Scripture to replace toxic thoughts.

Step 3: Active Practice. Preview your 'active practices'. It can begin to get familiar and boring. Renew your mind and intention as you practice them today.

Prayer

"God, I do not want pain in my life; my nature is to run from it at all costs. Thank You for teaching me that there is a purpose in the pain that I'm experiencing. Thank You that although so much of my pain is a result of my poor choices, You are still with me and never leave me or forsake me. I know that I can't see the big picture so I trust You, Lord. I trust You in the midst of the pain. I trust that You will work all things out for Your glory. I trust that You will always provide a way of escape when I feel like my back is against the wall. I thank You that You always provide a way of escape when I feel like I'm going to crumble under the weight of my pain, my pressure, or my problems. You promise that You will never leave me or forsake me. So I find solace in the fact that You are always right here with me. I no longer need You to take away my pain, but I now know that You will give me the strength to bear up under it. I would much rather suffer this pain of inconvenience, of a rumbling tummy, of going without my comfort foods, than suffer the pain of regret. You are my strength when I grow weak. You are my all in all! In Jesus' Name. Amen."

What To Do Today

- Start your morning with a glass of lemon or ACV water.
- Reflect on any anxiety that arises when you think of living sugar free. Pray about it and turn it over to God.
- Track your active practice today.
- Drink seven to eight cups of water and/or herbal tea.
- Get a good night's sleep (at least seven hours).
- Can you begin to carve out some time for light exercise?

Planning for Tomorrow

- Review the eating guide.
- Do you have all of the foods you need?
- Do you know exactly what you will be eating tomorrow?

Additional Scriptures

"For I consider that the sufferings of this present time are not worth comparing with the glory that is to be revealed to us."
Romans 8:18 (ESV)

"The Lord sustains him on his sickbed; in his illness you restore him to full health." Psalms 41:3 (ESV)

"I can do all things through him who strengthens me."
Philippians 4:13 (NASB)

Day 19: The Gift of Peace

Scripture Reflection

"Come to me, all who labor and are heavy laden, and I will give you rest. Take my yoke upon you, and learn from me, for I am gentle and lowly in heart, and you will find rest for your souls. For my yoke is easy, and my burden is light."
Matthew 11:28-30 (ESV)

Jesus promises you peace. Then why does it always seem to elude you? Why are you so stressed out and frustrated with so many aspects of your life if you've been given a gift of peace?

You may be feeling that you will finally have peace when you're able to overcome this sugar habit that's been plaguing you for most of your life, when you can stop binging, you attain the perfect weight, you learn to be obedient to God, you can finally slow down. Or when you retire!

You say to yourself, "How can I possibly have peace when I keep messing up and breaking my boundaries every day?" Or when I...? Truth is, this kind of peace you're seeking will probably never come.

But the good news is that God offers you peace in the midst of your circumstances. He doesn't want you to wait until you get things right before you can have peace or rest. He's offering it to you right now.

This might be why you struggle to find peace. You need to come to a better understanding of the peace that Jesus offers you.

- Peace is not found in a sugar-free life.

- Peace is not found in a good weigh-in every Wednesday.
- Peace is not when you've planned out all your meals.

Peace is the knowledge of the fact that Christ is with you when you fail to plan, when you weigh-in, and when your diet is less than stellar. You need to understand that God does not offer you a life of luxurious ease. He offers you a shared yoke with the brunt of the weight falling on Jesus' shoulders. You're still doing the work, but Jesus is doing the heavy lifting. That is what true peace means.

Reflect

Step 1: Pause. What threatens to steal your peace? Journal your response.

Step 2: Pray. Journal one or more scriptures that will minister to you and restore your peace.

Step 3: Active Practice. As you go about your day, notice what steals your peace and implement an active practice.

Prayer

"Lord, I look to You for whatever may come my way. I receive Your gift of peace by understanding that You are with me and You do all of my heavy lifting. You give me peace, not as the world offers it but as Your Word promises. So I cast my cares on You and give no thought about yesterday or about tomorrow. My only thought is about how You are guiding me at this present moment. Whenever I'm stressed, worried, anxious or afraid, help me remember to run to You. You're the only one who can calm my fears and put my mind at ease. Whether in everyday mundane matters or serious heavy matters, I know You will give me Your peace that surpasses all understanding. And when I draw close to You, I know with confidence that You will always be with me. In Jesus' Name. Amen."

What To Do Today

- Start your morning with a glass of lemon or ACV water.
- Reflect on what threatens to steal your peace and pray against it.
- Track your active practice today.
- Drink seven to eight cups of water and/or herbal tea
- Get a good night's sleep (at least seven hours).
- Can you begin to carve out some time for light exercise?

Planning for Tomorrow

- Review the eating guide.
- Do you have all of the foods you need?

- Do you know exactly what you will be eating tomorrow?

Additional Scriptures

"I have said these things to you, that in me you may have peace. In the world you will have tribulation. But take heart; I have overcome the world." John 16:33 (ESV)

"Now may the Lord of peace himself give you peace at all times in every way. The Lord be with you all." 2 Thessalonians 3:16 (ESV)

"You keep him in perfect peace whose mind is stayed on you, because he trusts in you." Isaiah 26:3 (ESV)

Day 20: One Bite Is Too Much

Scripture Reference

"But clothe yourselves with the Lord Jesus Christ, and make no provision for [nor even think about gratifying] the flesh in regard to its improper desires." Romans 13:14 (AMP)

I read a joke, or maybe someone told me, I can't remember, anyway it said, "I'm allergic to sugar — it makes me break out in fat." This made me chuckle at first, but then I thought about it. It's actually not funny at all — it's true. It would be so much easier if you were allergic to some of the foods that trigger you. It would be a no-brainer. You would not eat them because doing so could result in serious illness or even death! Intellectually, you should treat some foods like a deadly allergy because that's what they are. Granted, the effect is not immediate, like you would go into anaphylactic shock and die, but statistics prove there are many deaths associated with unhealthy eating habits.

In her book, *Taste for Truth*, Barb Raveling recognizes that you need to set hard boundaries with some foods. No one would ever tell an alcoholic that it's okay to drink on the weekends or to break their boundaries because of birthdays, special occasions, and vacations, yet you seem to always be making special allowances for these exceptional circumstances. Truth is, these exceptional circumstances are more the rule than the exception.

Romans 13:14 says to make NO provisions for the flesh. Not some provisions, not occasional provisions, but NO provisions. Period. This hardline can only be practiced when you clothe yourself in the Lord by spending time in the Word, renewing your mind, and obeying His Word.

It's time for you to get over the lie that 'one bite won't hurt'. It's time to stop telling yourself that 'you deserve it.' One bite will hurt, and what you deserve is to be in excellent health that glorifies God.

If you've been struggling with sugar or your weight for most of your life, then you can't continue to make provisions for your flesh. You will lose every time. If you're already thinking of all the foods you will enjoy after this detox is over, recognize that you're not ready to enjoy these foods. As you remain vigilant you will be victorious, but it may not look like what you think. Your promised land may never include trigger foods, like pasta and pizza — just like an alcoholics' promised land may never include alcohol. This may feel unjust to you. Take your frustration to God and allow Him to give you peace in this area of your life.

In the meantime, recognize that one bite is too much and a thousand will never be enough. You'll see that your only and best option is to seek satisfaction in Christ alone.

Reflect

Step 1: Pause. In the past, what happened when you had just one bite or one taste of a 'trigger' food? Capture your thoughts.

Step 2: Pray. What toxic thoughts spring up when you think about your favorite food that you used to overindulge in? Use Scripture to replace your negative thoughts about enjoying just one bite or returning to certain foods after the program is over.

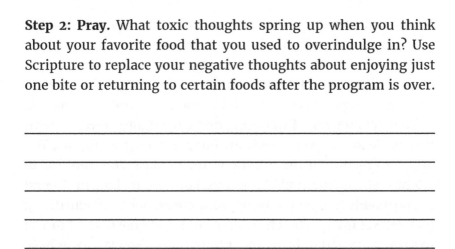

Step 3: Active Practice. As you go about your day, be sure to complete your active practice. The more you can do it, the more successful you will become at eliminating your toxic thoughts. Is there a specific active practice you will do for this new toxic thought? If not, continue in the active practice that you've been doing. Record it on your Active Practice Tracker and track how many times you performed it.

Prayer

"Dear Lord, I thank You that Your love is the only thing that will truly satisfy me. I come to You this morning, exposing my emptiness. This is a place that's deep inside me, and it feels bottomless and insatiable. I confess to trying really hard to find something that will fill the void, Lord. I've attempted to find satisfaction for that place in many different people, places, and things; in tastes, textures, and volumes. But no matter what I try I'm still left empty, incomplete, and hungry. These counterfeits do provide a temporary fix and work as a band-aid, giving me short-lived relief. But in all my efforts, all I've ultimately found is frustration, pain, and more problems. Lord, I confess that I've bought the lies that say I need some external thing to complete me. I've believed that I can satisfy the deep hunger

of my soul through my mouth, and I'm so sorry for how this must hurt You. Lord, I'm shaking off the shackles and choosing to believe the truth that I am complete in YOU! I'm choosing to surrender to Your Holy Spirit and declaring myself powerless over these substances and habits that are harmful to me and to Your relationship. I'm calling on Your mighty power to fight this battle for me! You satisfy my hunger! I am grateful that You put this craving for the infinite in me because You want me to relentlessly pursue You! Thank You, Lord, for making me Yours! Fix my bodily hunger on the appropriate amounts of nourishing fuel and set my spiritual hunger on You! Help me to trust in You to satisfy me and to bring me into the promised land You have for me. In the Holy Name of Jesus, Amen."

What To Do Today

- Start your morning with a glass of lemon or ACV water.
- Identify what foods will trigger you to eat more sugar.
- Track your active practice today.
- Drink seven to eight cups of water and/or herbal tea.
- Get a good night's sleep (at least seven hours).
- Can you begin to carve out some time for light exercise?

Planning for Tomorrow

- Review the eating guide.
- Do you have all of the foods you need?
- Do you know exactly what you will be eating tomorrow?

Additional Scriptures

"Beloved, I urge you as sojourners and exiles to abstain from the passions of the flesh, which wage war against your soul."
1 Peter 2:11 (ESV)

"And those who belong to Christ Jesus have crucified the flesh with its passions and desires." Galatians 5:24 (ESV)

"All you need to say is simply 'Yes' or 'No'; anything beyond this comes from the evil one." Matthew 5:37(NIV)

Day 21: Perseverance and Maintenance

Scripture Reference

"After the wall had been rebuilt and I had set the doors in place, the gatekeepers, the musicians and the Levites were appointed. I put in charge of Jerusalem my brother Hanani, along with Hananiah the commander of the citadel, because he was a man of integrity and feared God more than most people do. I said to them, 'The gates of Jerusalem are not to be opened until the sun is hot. While the gatekeepers are still on duty, have them shut the doors and bar them. Also appoint residents of Jerusalem as guards, some at their posts and some near their own houses." Nehemiah 7:1-3(NIV)

In our Weight Loss God's Way online program (weightlossgodsway.com), I offer an entire devotional called Strong Faith, Strong Finish that teaches us about perseverance and endurance. In this devotional, we study the life of Nehemiah and we learn of his tenacity and determination to see a task through to completion, even in the face of opposition, setbacks, and challenges. Now more than ever, you will need grit and determination to persevere as there may be the temptation to jump back into your old ways once this detox is over.

For 150 years, the walls of Jerusalem lay in ruin! Its walls were broken down and the gates burned with fire. No one had the faith and courage to believe that these walls could ever be rebuilt until God called Nehemiah. After much prayer and hard work the walls were rebuilt but Nehemiah recognized his job was not finished.

It would have well been within Nehemiah's right to throw a big party for his hard work. No one would fault him for that. Yet after the wall was rebuilt, Nehemiah knew that it was not yet time for a celebration. There was still much work to be done to ensure that this situation would never repeat itself.

He understood that achieving the goal was not the final destiny. It's simply a big milestone on the journey, and there was still much work to be done. He also understood that the physical foundation would only be as strong as the spiritual foundation, so he went straight to work to now build a strong spiritual foundation for the walls.

Now that the detox is over, recognize that this is not your final destination. There's more work to be done to maintain your spirit-filled and sugar-free lifestyle.

Step 1. Determine what your new maintenance boundaries will be. Be as specific as possible. E.g., *I will continue to eat approximately125 grams of carbohydrates per day; I will allow myself to eat 150 grams on the weekends and 100 grams between Monday-Friday.*

Setting these maintenance guidelines will take a lot of practice. You may try it and find that it was too stringent or too lenient.

Whatever boundaries you set make them 'hard' boundaries, meaning that they are set in stone. They are not negotiable. If you find that you're not able to stick to them, adjust them until you find a goal that will challenge and inspire you but not make you feel bound. This will require a lot of prayer to find the boundary that works for you.

Reflect

Step 1: Pause. As you reflect on this detox, think about how much sugar/carbohydrates you will consume going forward.

Step 2: Pray. Commit your new boundaries to prayer.

Step 3: Active Practice. As you go about your day, be sure to complete your active practice. The more you can do it, the more successful you will become at eliminating your toxic thoughts. Is there a specific active practice you will do for this new toxic thought? If not, continue in the active practice that you've been doing. Record it on your Active Practice Tracker and track how many times you performed it.

Prayer

"Lord, I thank You for the breakthroughs that You continually give me. I thank You for rebuilding my temple. The tests, the trials, the setbacks are all opportunities to grow closer to You and to learn to trust You more. Now as I continue to move forward, let me never grow weary in my commitment to my health. Keep me mindful, keep me purposeful, and keep me watchful so that

I don't revert to old habits. Give me wisdom so that I know when my tank is running low and I might become vulnerable against attacks of the enemy. Let me be present in Your presence as I go about my day so that I can remain strengthened in You. Let obedience to You be my inspiration and motivation to keep pressing forward every day. I thank You, Lord, for being my strength and shield. With You, I am victorious. In Jesus' Name. Amen."

What To Do Today

- Start your morning with a glass of lemon or ACV water.
- Begin your new maintenance plan and get clear on your new boundaries.
- Track your active practice today.
- Drink seven to eight cups of water and/or herbal tea.
- Get a good night's sleep (at least seven hours).
- Can you begin to carve out some time for light exercise?

Planning for Tomorrow

- Review the eating guide.
- Do you have all of the foods you need?
- Do you know exactly what you will be eating tomorrow?

Additional Scriptures

"And let us not grow weary of doing good, for in due season we will reap, if we do not give up." Galatians 6:9 (ESV)

*"For you have need of endurance, so that when you have
done the will of God you may receive what is promised."*
Hebrews 10:36 (ESV)

*"And I am sure of this, that he who began a good work in
you will bring it to completion at the day of Jesus Christ."*
Philippians 1:6 (ESV)

Post Challenge Day 1: Food Reintroduction

Scripture Reflection

"Be sober, be vigilant; because your adversary the devil, as a roaring lion, walketh about, seeking whom he may devour."
1 Peter 5:8 (KJV)

Confession ... I've been known to celebrate a detox with a sweet treat. **That's never a good plan**.

It's so easy to revert to old habits, and that's why the apostle Peter reminds you to remain sober and vigilant. There will never be a day when you should let your guard down. This does not mean that you have to be afraid of food. But it does mean that you have to always pay attention. Just like you always check for traffic before crossing the street or make sure that your doors are locked before going to bed, the same is true for your daily eating habits — always pay attention.

Now that you've finished the detox, you're probably wondering how to ease back into your 'normal' life.

Ultimately, it's up to you to choose what and how often you'll add certain foods back into your diet now that you're a lot more **mindful** of your choices, rather than being held captive by your sugar cravings.

As you slowly reintroduce foods into your routine, it's important to pay attention to how the foods you eat make you feel. Only reintroduce new foods one at a time for a few days. As you introduce the food, ask yourself the following questions:

- Did this food satisfy me?
- Did it energize me or did it make me feel sluggish?
- Does it cause me any gas, bloating, or abdominal discomfort?
- Did this food cause mood swings?
- Did this food trigger sugar cravings?

If you feel good after consuming a food after answering all of the questions above, then go ahead and add it back to your eating routine. Then continue to 'test' foods one by one.

If you eat something that triggers cravings, that will become one of your trigger foods that should not be part of your meal plan, ever! Yes, there are some foods that you will have to accept are not for you. I tell myself (and others) that I'm allergic to them. It saves having to explain myself.

You know all too well the fears that come up once you end a program. Can I maintain it? What do I do for my birthday? This time is different. Now that sugar is out of your system and now you're skilled at your 3-Step Reset© (Pause, Pray and Practice), now it's a matter of rinse and repeat.

When the fears come up and try to pull you back in, simply pause, take a deep breath, confess your identity in Christ, and move right into your active practice.

In the past fear would overtake you, but not anymore. You're committed to staying on course, and if even you happen to go off course, you're not going to sweat it. You'll just get back on track as soon as you can. Keep on going, recognizing that going off course **is** part of the process. Remember, this journey is about progress not perfection.

As you move forward towards your Spirit-filled and Sugar-free lifestyle, keep these guidelines that will either supplement or replace your current healthy lifestyle.

Reflect

What foods are you committed to no longer consuming?

What foods will you 'test' and see how if you will allow them back into your healthy eating plan?

What will be your active practice before you eat foods that could potentially trigger cravings?

Prayer

Dear Lord, I thank You for Your grace. I thank You for Your love and mercy that keeps me in all circumstances and situations. As I transition out of this detox, it reminds me of how good it felt when I sought my satisfaction in You and not in sugary foods.

Remind me that only You can satisfy me. When it seems like You're far from me and I can't hear Your Voice, speak to me. When the promises and commitments I made to You have fallen by the wayside and I want to revert to my old habits, remind me. Lord, You know my heart.

You know my true desire to please You and live for You, so be gracious with me as I learn Your ways. I thank You that You will never leave me or forsake me, and I commit to always return to You regardless of how many times I fall away. Your Word says that You will always forgive me and cleanse me, so I stand on Your Word. I thank You that as I end this today, I'm reminded each day is a fresh opportunity to live in Your presence Spirit-filled and sugar-free! In Your Son's Name. Amen."

Additional Scriptures

"How sweet are your words to my taste, sweeter than honey to my mouth!" Psalms 119:103 (NIV)

"For it was I, the LORD your God, who rescued you from the land of Egypt. Open your mouth wide, and I will fill it with good things." Psalms 81:10 (NLT)

"He fills my life with good things. My youth is renewed like the eagle's!" Psalms 103:5 (NLT)

"And the Lord will guide you continually and satisfy your desire in scorched places and make your bones strong; and you shall be like a watered garden, like a spring of water, whose waters do not fail." Isaiah 58:11 (ESV)

Post Challenge Day 2:
Continual Spiritual Renewal

Scripture Reference

"Finally, brothers, whatever is true, whatever is honorable, whatever is just, whatever is pure, whatever is lovely, whatever is commendable, if there is any excellence, if there is anything worthy of praise, think about these things."
Philippians 4:8 (ESV)

Confession time here ... I've been known to drive for miles and miles (kilometers here in Canada) before putting gas in the car. When that 'low fuel' light came on, I often ignored it for at least a couple of days. It became like a game of 'let's see how far I can go before I run out of gas.' What an overrated game when you think about it. Aside from the adrenaline feeling that I survived another trip, letting the car run on fumes is always a bad plan.

Sadly, waiting to fill the tank until I'm running on fumes was an all too familiar pattern in my life, too. I don't often recognize when I'm doing it but it would show up as discouragement, dissatisfaction, apathy, and wanting to abandon my goals. I felt tired, lacked energy, and would start looking for short-cuts in everything I did. Then I'd keep doing things and eating foods to try to make myself feel better, but nothing worked. You know that feeling where no matter what you eat you just can't get full? It happens spiritually as well as physically.

But now you have tools so that you never have to run on empty or allow your sugar cravings to hold you hostage. Continue to practice your 3-Step Reset© (Pause, Pray, Practice) to keep yourself from wanting to quickly fill up with sugary foods.

Stay FULL with the Word of God. As Philippians 4:8 reminds us, much of your Christian life will come down to what thoughts you fill your mind with. Paul reminds you to keep your mind full of the right things.

When you're full, you don't have to push the limits to see how long you can run on empty. God's Word will provide you with so much satisfaction, encouragement, and peace that you won't feel the need to push past your limits.

That's why you will continue to practice the 3-Step Reset©. As you wake up in the morning, be intentional about committing the day to God. Then as you go about your day, talk to God all day long. Keep an ongoing dialogue with Him. Take Him with you wherever you go. He wants to be with you — imagine that! The God of the Universe wants to spend time with you; He wants to abide in you (John 15:5).

Reflect

What habits will you practice to 'stay full'?

What foods will you 'test' and see how if you will allow them back into your healthy eating plan?

Prayer

"Lord, I thank You that You fill me completely with joy and peace. I trust You to meet all of my needs — emotionally and spiritually. I will continue to feast on Your Word so that I will never allow myself to go running on empty and that I will never operate in excess either. You give me just what I need. I will hide Your Word in my heart. It is like a lamp that guides me in the darkness. When I'm feeling stuck, it's Your Word that will see me through. Although it's never my intention, the next time I'm running on fumes let me run to You for nourishment instead of seeking things that don't satisfy me. In Your Holy and precious Name, I pray. Amen."

Additional Scriptures

"Beloved, I urge you as sojourners and exiles to abstain from the passions of the flesh, which wage war against your soul."
1 Peter 2:11 (ESV)

"And those who belong to Christ Jesus have crucified the flesh with its passions and desires." Galatians. 5:24 (ESV)

"All you need to say is simply 'Yes' or 'No'; anything beyond this comes from the evil one." Matthew 5:37(NIV)

Post Challenge Day 3: Continual Mind Renewal

You've learned a powerful tool to rewire and retrain your brain. I pray that you can see that you are not captive to your thoughts. They can be changed as you allow God to change the way you think.

This is a wonderful start, but it's not the end. Like you brush your teeth every day, shower each day and exercise regularly, renewing your mind is a daily process that you will continue to practice for the rest of your life.

Remember that you have an enemy that is always looking to steal, kill, and destroy (John 10:10) and his method of attack from the beginning of time is always through your mind, by planting seeds of doubt and discord (remember Adam and Eve in Gen. 3:1).

That's why your responsibility is to remain vigilant (John 10:10). There will never be a day that you don't need a reset. There will never be a day that you don't have to put on the mind of Christ (Phil 2:5). It's God's gift to you, but without putting it on you leave yourself vulnerable. Like forgetting to open your umbrella in the rain, you have an indispensable tool to protect you from the elements. You just have to use it.

Continue to practice the 3-Step Reset© to root out toxic thoughts so that they no longer sabotage you. This will be an ongoing process and powerful tool that you will continue to use for the rest of your life.

Remember that these first 21 days are a great start. You've started the process of changing your brain and have built a

long-term thought that will serve you well, but this is not the end. I suggest two more cycles of 21 days for your sugar-free lifestyle to become an ingrained habit. Keep on taking it one day at a time.

Prayer

"Lord, I thank You for this challenge and devotional. I thank You for changing my mind, my attitude, and even my tastebuds. I thank You for the changes that are yet to come because I can feel in my spirit that there's so much more that You want to do in me and through me. Let my new cravings be for You and You alone. This journey has been about so much more than food. I'm so grateful that You've shown me that it's all about You. There is nothing too hard for You and there is nothing that I can't overcome with You by my side. Help me to take it day by day. When I backslide, let me quickly run back into Your loving arms and not spend too much time condemning myself, but help me to be quick to repent. In Your Name I pray. Amen!"

Your New Approach

"Therefore, if anyone is in Christ, the new creation has come:
The old has gone, the new is here!"
2 Corinthians 5:17 (NIV)

Congratulations, my friend! You have begun to rewire your brain, realign your spirit, and retrain your taste buds to crave nutritious foods instead of sugary unhealthy foods. You're well on your way to making changes that will serve you for the rest of your life.

You no longer have to live under the bondage of being at the mercy of your sugar cravings. You are an overcomer. Repeat after me.

I am an overcomer, I am not overcome by my strongholds!

My mess is my message!

My stronghold is now my stepping stone!

I am a victor, not a victim!

When the cravings come, when the temptations come, when your old nature threatens to remind you of your past behaviors, pause and calm your nervous system, pray and align your soul with your spirit, and then stand firmly and boldly in your new identity in Christ. With this new awareness of who you are in Christ, you will win every time. THANK YOU, JESUS!

Section 3. The Sugar-Detox Meal Plan

Now let's get practical. You're here because you are aware that you consume too much sugar and you needed a solution to stop eating so much of it.

I hope I've shown you that you've got to start at the root first, which is understanding the spiritual roots of overconsumption of sugar or anything else in your life that has become an idol.

With that understanding I know that you also need a practical guide or plan, and that's what this section will provide you.

It is a base plan that will highlight what Spirit-filled eating looks like which are the ten guidelines I lay out next. Follow these guidelines once you've completed the 3-Day Kickstart. You can continue to follow the guidelines as a maintenance plan once you've achieved your healthy weight.

Please note that it is only a general plan. Everyone has different needs, goals, metabolism levels, activity levels, and even different levels of sensitivity to sugar. Feel free to adjust this plan according to your body's unique needs. These guidelines contain approximately 100 grams of net carbohydrates, which is a good number for most people. If you are currently practicing a **consistent** keto lifestyle, then this eating guide will not work for you since it will take you out of ketosis.

Here are your Spirit-Filled and Sugar-Free Guidelines

1. Maintain Your Carbohydrate Intake to or 100 Grams

This is the most basic and simplest guideline to follow for living a spirit-filled and sugar-free lifestyle.

Consuming one hundred grams of net carbs per day, it's doable for most people to follow. One hundred grams is low enough to maintain your metabolism without the negative side effects that often accompany very low-carbohydrate diets such as mental fogginess, crabbiness, or lack of energy.

When you maintain one hundred grams of carbohydrates every day, there's no reason to avoid nutritionally healthy fruits, berries, vegetables, and whole grains as is often the case with very low carb diets. It opens up your diet to a wider variety of meal choices without feeling like you have to live on meat and vegetables every day. Most people abandon their healthy eating plans because they feel deprived, but with one hundred grams this will not be the case.

You may choose to go below one hundred grams, which is absolutely your choice as long as you are getting the results you desire. Although it may not be for everyone, it's a great place to begin.

A simple breakdown for 100 net grams of carbs could be:

Breakfast - 25 grams

Lunch - 25 grams

Dinner 25 grams

Snack 1 - 10-15 grams

Snack 2 - 10-15 grams

Try to space out your carbs as much as possible. Consuming one hundred in one serving (which is not that difficult to do) can trigger sugar cravings.

2. Eat SIMPLE, WHOLE Foods

With the exception of a few foods, you can't go wrong when you eat simple whole foods that God gave us in their natural state. Fruits, vegetables, nuts, meats, and healthy grains rarely trigger sugar cravings.

Avoid low-fat or low-carb foods and eat foods in their most natural state with minimal processing. Simple foods have lots of color. Just think of the variety of colors you see in vegetables. How many different servings of vegetables can you eat each day and each meal?

Fresh fruits are a much healthier option than cakes and desserts, but you still have to be mindful of some of them. Eat lower sugar fruits such as blackberries, blueberries, and strawberries and minimize consumption of sweeter fruits such as mangoes, pineapples, and watermelon. Stay away from dried fruits such as raisins, cranberries, dates, and apricots. **As a general rule,** enjoy two servings of fruit per day. This will vary depending on your activity level, tolerance for sweets, and daily caloric consumption. You can view the list below to see what constitutes a serving.

In keeping with the principle of consuming whole foods, try to eat your carbohydrates whole instead of drinking them. Nothing will rack up the sugar calories quicker than drinking fruit juice (sodas, or alcohol), plus you get the benefit of the fiber when you consume the fruit whole. I read somewhere that the average American drinks four hundred calories a day on a daily basis!

Here are a few suggestion to eliminate sugar from your drinks:

- Drink water with a hint of lemon or infused with some other fruit.

- If you don't like the taste of water, try carbonated water.

- If you enjoy sweet teas, replace it with sparkling water and lemon slices.

- Reduce the size of your coffee, which will automatically decrease the amount of sugar if you need to sweeten it.

- Use unsweetened almond milk in your protein shakes.

- Limit or eliminate alcohol consumption, especially mixed drinks.

3. Minimize Sugar by Minimizing or Eliminating Fast Foods, Junk Food, and Unhealthy Fats From Your Diet

Although you may not be able to eat only whole foods all the time, dramatically decreasing your processed food consumption will automatically decrease your sugar consumption. Processed foods are foods that are not found in their natural state — foods that are packaged, canned or boxed, and therefore contain additives, artificial flavorings, and other chemical ingredients and of course, sugar.

Here are some useful tips:

a. Processed and sugary foods are usually found in the center aisles of your grocery store — cereals, cookies, chips, canned soups. Natural foods are usually found in the outer aisles — fruits and vegetables, meats, and other single-ingredient foods. As a general rule, do most of your shopping from the perimeter of the store.

b. You can tell how processed a food is from the length of the ingredient list. If you look at a box of your favorite cereal you will see a list of over twenty ingredients, many of which most of us can't even pronounce. Choose foods with as few ingredients as possible.

c. Try not to have sugar show up in the first few ingredients. The lower down on the list sugar appears, the less sugar it will contain.

d. A good rule of thumb to follow is, "If it came from a plant, eat it. If it was made in a plant, don't eat it."

4. Enjoy Foods From a Variety of Food Groups

Unless you have very specific requirements or restrictions from your doctor, beware of meal plans that eliminate entire food groups. Our bodies need nutrients from proteins, carbohydrates, and fats. Since no single food is perfect, you need a mix of all foods; eliminating entire groups will lead to nutritional deficiencies.

Having said this, not all proteins, carbs, and fats are created equal. So you will have to learn which ones are best for your unique needs.

A diet high in protein and healthy fat will leave you feeling satisfied and decrease your sugar cravings. The more high-carbohydrate foods you eat, the more you will crave them. As a general rule, try to balance out your diet so 40% of your calories come from carbohydrates, 30% come from fats and 30% come from protein. Your protein servings can be even lower if you have significant amounts of weight to release.

Lastly, try to always consume protein with your carbohydrate intake to slow down the rate at which the sugar in the carbohydrate will enter your bloodstream.

For example:

- have high fiber crackers with cheese
- carrot sticks with hummus
- berries with Greek yogurt
- celery with almond butter
- protein shake

Note: If you practice a vegetarian lifestyle, pay attention to maintaining healthy alternative sources of protein. Vegetarians or vegans often over-consume carbohydrates and can often struggle with balancing their meals. If you're vegetarian or vegan, you might consider getting professional advice from a dietitian.

5. Eliminate All White Products and Flour Products

There's an actual diet called the "Eat Nothing White Diet." This diet suggests you eliminate all white rice, white potatoes, white beans, white sugar, and any product made with refined

sugar and white flour products like white bread or pasta. This is another simple guideline to follow if you forget everything else.

Remember, this does not give license to eat as much brown rice or whole grain foods as you want. You will still need to moderate your total carbohydrate intake.

The exceptions to flour products are flours made with nuts such as almond flour or even coconut flour. Give them a try, but if you find that they trigger sugar cravings then dial them back or eliminate them altogether.

6. Eliminate/Moderate All Natural and Artificial Sweeteners

There are three types of sugars you will want to pay attention to:

Naturally occurring sugar

Naturally occurring sugars are found naturally in foods such as **fruit (fructose) and milk (lactose).** Honey and maple syrup are also considered natural sugars. Regardless of their health benefits overconsumption of any of these sugars will spike blood sugar levels, so moderate your intake of them. As a general rule, two servings of fruit (depending on the type of fruit of course) is adequate for most women. See the food guide below for your list of Spirit-filled foods that contain naturally occurring sugars.

Refined sugars

This one's easy. Eliminate all consumption of foods that contain refined or added-sugars. These include all candies, cookies, cakes, and even white breads. This also shows up in

hundreds of foods such as ketchup. Refined sugars are often hidden in food labels and can appear in a variety of forms. For more information, you can download the list of hidden sugar at spiritfilledandsugarfreebonus.com

Artificial Sugar/sweeteners

Have you ever noticed that you can eat more 'sugar-free' foods than regular foods? There are a couple of reasons for this. First of all, psychologically, you give yourself more permission because you tell yourself that it's healthier for you. So you eat more, which racks up the sugar and calorie count. Second of all, because even though you're not getting the calories you are still training yourself to enjoy and find satisfaction in sweets, so you will continue to crave sweets.

Pay attention to artificial sweeteners in diet drinks, mints, and even in foods that you would not expect to find artificial sweeteners such as protein powers and salad dressings just to name a few.

Having said that, know that not all artificial sweeteners are created equal. There are a few sweeteners that will not increase your blood sugar levels such as monk fruit, stevia, or erythritol. Use these sparingly for special occasions as long as they don't trigger your sugar cravings. If after eating them you find yourself craving more, then back off from eating them in the future.

7. Understand Your Trigger Foods

Trigger foods are those that, when eaten, make you crave more and send your diets into a total tailspin. They are foods that cause your blood sugar to rise and quickly fall, which creates a series of unfortunate events in your brain and body that lead

you to keep desiring the food. Trigger foods are rarely eaten because of true hunger.

Trigger foods vary from person to person and are based on your past relationship with the food. They can be tied to a certain habit such as always having dessert after dinner or always eating chips while watching TV. Or they can be tied to certain emotions such as stress or boredom.

Avoid consuming your trigger foods even in moderation. In my experience, some people (food addicts) may need to avoid some foods for the rest of their lives, while some people can learn how to moderate their foods. If you suspect that you're a food addict, take this simple quiz from my friend, Pam Masshardt, author of the book Sweet Surrender. Go to http://www.fulloffaith.com/food-addiction.

If you think it might be a matter of learning new strategies, habits and mindsets, be sure to check out my Breakthrough book. It will help you overcome any stronghold by grounding your identity in God and allowing Him to heal you from the inside out. Go to cathymorenzie.com to learn more.

8. Practice Mindful Eating

There are two aspects to mindful eating. First is to pay attention to what you're eating. You must educate yourself on where sugar is lurking in your food.

It may not seem like a big deal but things like ketchup, salad dressing, mayonnaise, and barbeque sauce can make the difference between battling uncontrollable cravings or feeling satisfied. Check out the bonus gift (spiritfilledandsugarfreebonus.

com) to see other names for hidden sugars. As a rule of thumb, "if in doubt, leave it out".

Secondly, you will also need to practice mindfulness habits. Are you always the first person finished because you eat so quickly? Or are you guilty of always eating in front of the TV? How do you feel after eating a meal? Do you eat when you're angry or stressed? All of this will affect your digestion and set the stage for whether your next meal will be healthy or sugar-laden. As you learn to eat mindfully you will learn to slow down and enjoy your food more, which will teach you to find satisfaction in what you eat as well as help your body to better process the foods that you eat.

9. Drink Plenty of Water

The Earth is seventy percent water. Your body is eighty percent water. It stands to reason that water is essential for life. Water is the body's transportation vehicle. It is used to move nutrients to the one hundred trillion cells in your body, to move waste and toxins from your cells to your kidneys, then out of your body, and it helps your body to eliminate fat. Drinking water will also curb your appetite and keep (sugar) cravings at bay.

10. Practice Grace-Filled Eating

Spirit-filled eating requires a lot of grace and compassion with ourselves. Unfortunately, as human beings, we have an uncanny knack for taking what was meant to be simple and pleasurable and turn it into a complicated, overwhelming mess of do's and don'ts. Food is joy, food is medicine, food is pleasure, food is sustenance. It's time to stop demonizing and vilifying food

and recognize that it's a gift from God to be enjoyed. Practice grace-filled eating by following the 80/20 rule (unless it's a trigger food). Grace-filled eating means that you approach eating with ease and joy because you appreciate that food is a gift from God. It means that when you occasionally break your boundaries you'll use it as an opportunity to understand what the deeper need was (were you stressed, anxious, or tired?), and then practice the 3-Step Reset© you learned earlier in the book.

The goal is to enjoy a glass of wine or dessert on occasion without throwing yourself into a tizzy. Do you really want to spend the rest of your life tracking your food and counting calories?

Lastly, do you pray before eating? As you practice mindful eating, you will also learn to practice gratitude and thankfulness for what you eat. Be intentional about giving God thanks for what you're about to eat and acknowledge Him as your only source of satisfaction.

If you tend to rebel when you're given boundaries of what to eat or not eat, then I recommend you follow these guidelines above to help you live a spirit-filled and sugar-free lifestyle.

3-Day Kick-Start Guide

Here is your Spirit-filled food list for your three-day kickstart. It consists of three days of consuming fewer than 50 grams of net carbohydrates. Remember, net carbs are the total carbohydrate content in the food minus the fiber content.

Drinks	Protein
1 cup of black coffee per day	At least 3 servings of each the following daily
Unsweetened green, black or herbal tea (unlimited)	Chicken 4-6 oz
Min. 64oz of water (or ½ body weight in oz)	3 Eggs (up to 7 per week total)
	Seafood/Shellfish 4-6 oz
sodium-free sparkling water or club soda	Pork 4-6 oz
unsweetened almond milk	Tofu 4-6 oz
	Turkey 4-6 oz
	Legumes ½ c/ 4 oz
	Deli meats (in moderation- Avoid fillers, added sugar, MSG, sulfites, nitrates when possible

Vegetables Unlimited	Fruit
Arugula	Lemon or lime for cooking
Artichoke	
Asparagus	
Avocado (½ max daily)	
Bell pepper, green, chopped (raw)	
Bok Choy	
Broccoli	
Brussels	
Cabbage	
Carrots	
Cauliflower	
Celery	
Cherry tomatoes (10)	
Cucumbers	
Garlic	
Green Beans	
Jicama/radish	
Kale	
Lettuce	
Leeks	
Mushrooms	
Onions	
Olives (10 sm)	
Peas	
Pumpkin 1/2C	
Salsa	
Snow Peas	
Spinach	
Squash ½ cup (Spaghetti or Summer)	
Sprouts	
String beans	
Tomato 1/2C	
Water Chestnuts	
Zucchini	

Nuts/Seeds	Oils/Fat
5 g net carbs **twice daily:** Almonds- 1/2c Cashews- 2 T Coconut- 1C unsweetened Chia seeds 3T Flaxseeds 3T Hazelnuts 1/2C Hemp seeds Macadamia nuts- ½ Pecans 1C Pine nuts 1/2C Pistachios 3T Walnuts 3/4C **Seeds 1 oz** Pumpkin 1/2C Sunflower 1/2C Nut/seed butters 1T	**3 servings per day** **Cooking oils** Coconut oil 1 T Avocado oil 1T Olive oil 1 T Sesame oil 1T Butter 1 T Ghee 1T

Condiments	Other
Vinegar: Apple cider Balsamic Red wine Mustard Soy sauce	**Unlimited herbs & spices** including: Allspice Cinnamon Cloves Ginger Marjoram Rosemary Sage Tarragon Turmeric

21-Day Spirit-Filled Eating Guide

Here is your Spirit-filled Eating Guide. Use this to plan your balanced meals consisting of 100 grams or less of net carbohydrates. Remember, net carbs are the total carbohydrate content in the food minus the fiber content. If you want a done-for-you meal plan complete with recipes and shopping lists, be sure to upgrade to the online program. Go to spiritfilledandsugarfree.com

Drinks	Protein*
Coffee 2 cups	At least 3 servings of each the following daily
	Chicken 4-6 oz
	3 Eggs (up to 7 per week total)
	Seafood/Shellfish 4-6 oz
	Pork 4-6 oz
	Tofu 4-6 oz
	Turkey 4-6 oz
	Legumes ½ c/ 4 oz
	5-10 net carbs per serving
	Deli meats (in moderation- Avoid fillers, added sugar, MSG, sulfites, nitrates when possible
	Protein powder

Dairy	Vegetables
Cheese 1 oz	Arugula
	Asparagus
Laughing cow 1 wedge	Bok Choy
	Broccoli
Cottage Cheese ½ cup	Brussels
	Cabbage
Cream cheese 5T	Carrots
	Cauliflower
Milk ½ C/ 4 oz	Celery
	Cucumbers
whole ¾	Garlic
butter ¾	Jicama/radish
2% 1C	Kale
	Lettuce
Parmesan 1 T	Mushrooms
	Onions
Sour cream 3/4C	Peas
	Peppers
Unsweetened Greek or full fat yogurt 1/2C	Salsa
	Snow Peas
	Spinach
	Squash ½ cup (Spaghetti or Summer)
	Sprouts
	String beans
	Tomatoes
	Water Chestnuts
	Zucchini

Fruits	Nuts/Seeds
5-10 net carbs per serving	5 g net carbs
	Twice daily:
Apple 1 med	
Berries 1C	Almonds- 1/2c
Banana ¼ sm	Cashews- 2 T
Blackberries	Coconut- 1C unsweetened
Blueberries 1/4C	Chia seeds 3T
Raspberries	Flaxseeds 3T
Cantaloupe 3/4C	Hazelnuts 1/2C
Grapefruit ½	Hemp seeds
Cherries ½ cup or 10	Macadamia nuts- ½
Clementines- 2	Pecans 1C
Grapes ½ cup	Pine nuts 1/2C
Nectarine 1	Pistachios 3T
Orange 1 med	Walnuts 3/4C
Peach 1	
Strawberries 1/2C	Seeds 1 oz
Watermelon 1/2C	Pumpkin 1/2C Sunflower 1/2C
	Nut/seed butters 1T

Carbs/Starch	Other
10 g net carbs per serving	**Unlimited herbs & spices** including:
Breads	Allspice
Whole grain, multi-grain, rye- 1 slice	Cinnamon
	Cloves
	Ginger
Barley ¼ c	Marjoram
Brown rice ¼ c	Rosemary
Buckwheat	Sage
Couscous 1/3c	Tarragon
Corn ½ ear or ½ c niblets	Turmeric

Crackers, 6 whole grain, high-fiber (Mary's Gone)	**Condiments**
	Vinegar:
Millet ¼ c	Apple cider Balsamic
Oatmeal ¼ c	Red wine
Popcorn	Mustard
2 cups	Soy sauce
Quinoa ⅓ c	**Alcohol**
Sweet potato (yam) or summer squash 1 small	**Red Wine**
Grits ⅓ c	5 oz glass 3x a week
	Dark Chocolate
	1 oz daily (at least 65% cacao)
follow nutritional labels for other carbs not listed here	**Use Sparingly**
	Monk fruit
	erythritol
	stevia

Sample Meal Plan for Spirit-filled eating

The majority of your carbohydrates will come from vegetables, fruits, and starches, with a little also coming from dairy products.

Here are some suggestions for breaking down your meals:

Meal 1:

4-6 oz. plain non-fat yogurt or another dairy or breakfast protein

1 egg or another breakfast protein

1 oz. oatmeal or other starch

1 small/medium sized fruit

Meal 2:

1 grilled chicken breast or 4-6 oz. protein

6-8 oz. salad

1 cup fried cauliflower rice or 6-8 oz. or another low-carbohydrate vegetable, cooked or raw

1 tablespoon olive oil or another fat

Meal 3:

4 oz. of beef or another 4-6 oz. protein

½ cup brown rice or another 4 oz. starch

6-8 oz. salad

1 cup of broccoli or another low-carbohydrate vegetables, cooked or raw

1-2 tablespoon olive oil or another fat

Snack 1

¼ cup almonds or other 1 serving nuts or seeds

Snack 2 (optional)

Greek yogurt with ½ cup blueberries and ½ tsp monk fruit or 1 serving dairy with 1 serving fruit

Notes about the food list:

If it's not on the list, do your research. If in doubt, leave it out.

THANK YOU

Thank you for being motivated, courageous, inquisitive, and committed to go deeper in your health journey and uncover the missing piece— Christ!

I pray that these principles have been as much of a blessing to you as they have been for me

and the hundreds of thousands of women around the world who have experienced what it means to include God in their health and weight-releasing journey.

If you've been blessed by this book, then please don't keep it a secret!

There are millions of women who need to hear this message. Please take a moment to leave an honest book review so more people can discover this book as well.

This book has laid out a great foundation for you, but there's so much more for you to discover. Please keep in touch with me so that you can stay in this conversation and continue to make your health a priority —God's Way. Plus I'll send you a free copy of my '3 Steps to Overcoming Emotional Eating' guide when you enroll for my weekly devotional message on successful weight loss, God's way.

Receive my weekly posts at Cathymorenize.com

Leader's Guide

"Therefore go and make disciples of all nations, baptizing them in the name of the Father and of the Son and of the Holy Spirit, and teaching them to obey everything I have commanded you. And surely I am with you always, to the very end of the age." Matt 28:19-20 (NIV)

Thank you for answering the call to lead a group through the Spirit-Filled and Sugar-Free 30-day challenge and devotional.

Coming together as a group holds you accountable and provides an opportunity to develop consistency within your faith. The best way to learn is to teach. We believe that as you lead others, you will also continue to grow in the Lord.

Healthy by Design ignites and mobilizes leaders who want to use their spiritual gifts and skills so that others can be transformed by the truth of God's Word.

Know that when you say 'yes' to minister to others, you are changing and affecting not only their lives but also the lives of everyone they come in contact with. You will find that, as a leader, you will feel more connected with the devotionals as you take on a sense of ownership and responsibility and want to support your small group as much as possible.

You have the option of leading the challenge online or in an in-person group. As a leader, you must register your courses with us. Please register your group here:

https://www.cathymorenzie.com/become-a-bible-studyleader/

The 30-day challenge/devotional works best when participants work independently and follow up their independent study with leader-led small-group interaction either in person or virtually.

As the group leader, your responsibility is to facilitate discussion and conversation and make sure that everyone gets the most out of the devotionals. You are not responsible for having all the answers to people's questions or reteaching the content.

That's what the devotional is for.

Your role is to guide the experience, encourage your group to go deeper into God's Word, cultivate an atmosphere of learning and growth amongst a body of believers, and answer any questions that the group may have.

Tips to get the most from the Small Group Sessions

1. **It's about God.** Although we use biblical principles to guide us on how to address strongholds in our lives, at the end of the day remember that it's always about God. Your role as a leader is to always point everyone to the cross.

2. **Partner up.** Have your group choose an accountability partner to go through the devotional with. It's always more encouraging when you can connect with someone on a regular basis in addition to when you meet as a group.

3. **Keep a journal.** Encourage your group to use a supplemental journal. They can choose from an online journal like Penzu (penzu.com) or use old-school pen and paper. Either way, taking time to record your thoughts, feelings, inspirations, and directives from Holy Spirit is a great way to maximize the experience.

4. Be consistent. Meet at the same time and location each week. This will help the group to organize their time and their schedules. Try to select a time that works best for everyone.

5. Plan ahead. Take time prior to the weekly study to think about how you will present the material. Think about a story or example that would add to the material. Think about the most effective way to make use of the time.

6. Keep it intimate. Keep the small group small. I suggest a maximum of 12-15 people. This will create a more relaxed and transparent atmosphere so that people will feel safe to speak.

7. Be transparent. You can set the tone for the group by sharing your story. This will help people to feel safe and establish trust with them. When you speak, give personal examples and avoid phrases like 'some people' and 'Christians'.

8. Be professional. Always start and end the sessions on time. Communicate clearly if you see that you will be going over-time. Apologize and let them know how much you respect their time.

9. Bring lots of energy. Let your passion for studying God's Word be evident. Remember that your energy level will set the tone for the entire group, so bring it!

10. Pray. It might sound obvious, but make sure that prayer is an intricate part of the entire process. Pray at the beginning and end of every session. Feel free to call on others to lead the prayers. During the session you can have one person pray for the entire group, have one person open and another close, ask for requests, or select someone. You can also encourage the group to pray for one another. Lastly, don't forget to pray during the time leading up to the session.

11. **Keep it simple.** If the sessions get too complicated, people will find reasons not to attend. If you plan to serve snacks, keep it simple and nutritious. Don't plan weekly potlucks that will require the group members to do too much work.

12. **Be creative.** Feel free to add music, props, or anything that you feel will add to the environment and facilitate learning.

13. **Be comfortable.** Make sure there is adequate comfortable seating for everyone. Check the temperature in the room. Alert everyone as to where the bathrooms are located.

Preliminary Preparation

- Pray and seek the Holy Spirit on whether you should participate in this devotional.

- Determine with your group how long you will meet each week, so you can plan your time accordingly.

- Most groups like to meet from one to two hours.

- Promote the challenge and devotional through community announcements, social media, in your church bulletin, or simply call a few of your friends.

- Send out an email to a list or send a message on social media announcing the upcoming devotional and challenge.

- Prior to the first meeting, make sure that everyone purchases a copy of the devotional. Include a link where they can buy it.

- Have the group read Section 1 and the 3-Prep Days and be prepared to share their responses.

Suggested Group Plan

Because *Spirit-filled and Sugar-Free* is an independent devotional and challenge, the group discussion will incorporate a series of small discussions within the greater discussion. Feel free to customize the design to fit the needs of your group. The suggested plan is for a six week session. Following is the breakdown.

A Six-Week Session Plan

Session 1

1. Welcome everyone to the session and open with prayer.

2. Share a bit about yourself. Then go around the room and have everyone introduce themselves. Have each person share what their biggest challenge they experience when it comes to decreasing their consumption of sugar.

How does it impact their health? What are some of the consequences? What happens when they try to eliminate it?

3. Give an overview of the devotional and a brief overview of the Spirit-Filled and Sugar-Free challenge. Review all planning sections and Spirit-filled food lists and ask your group if they are ready to commit to the process.

4. Housekeeping Items:

- format for the session
- confirm dates and times
- where bathrooms are
- rules for sharing
- commitment to confidentiality

- attendance each week
- snacks (have volunteers provide)

5. Offer suggestions to get the most out of the devotional and detox.

Consider offering weekly incentives or prizes.

6. Stress the importance of trust and transparency.

7. Instruct the group to have completed the 3-Day Kickstart prior to the next meeting. Encourage them to carve out some time each day to complete the devotions

8. Ask the group for ideas of what they will be consuming during the detox.

9. Close the session in prayer.

Session 2

1. Welcome the group.

2. Start with an opening prayer.

3. Ask the group what insights/breakthroughs/testimonials they encountered as a result of what the Holy Spirit has been showing them.

Suggested Discussion Starters:

a. Discuss the 3-day Kickstart. What were their challenges and successes?

b. What did they learn that they will carry with them into the 21-day challenge?

c. What upcoming events will they need to work around?

4. Make a closing remark or statement to tie in the entire conversation.

5. Have the group read week one of the 21-day detox for next week's session.

6. End with a closing prayer.

Session 3

1. Welcome the group.

2. Start with an opening prayer.

3. Ask the group what insights/breakthroughs/testimonials they encountered as a result of what Holy Spirit has been showing them.

Suggested Discussion Starters:

a. What is your active practice?

b. How many times per day did you practice it?

c. Share one example when it was helpful.

d. Where have you experienced cognitive dissonance (double mindedness)?

e. How can you make sure that the Lord is your focus?

4. Make a closing remark or statement to tie in the entire conversation.

5. Have the group read week 2 for next week's session.

6. End with a closing prayer.

Session 4

1. Welcome the group.

2. Start with an opening prayer.

3. Ask the group what insights/breakthroughs/testimonials they encountered as a result of what Holy Spirit has been showing them.

Suggested Discussion Starters :

 a. Do you confront your challenges with worry or prayer?

 b. How do you or can you offer yourself as a living sacrifice each day?

 c. What need do you feel you're trying to satisfy when you go to sugar for comfort and satisfaction?

4. Have the group read week 3 for next week's session.

5. End with a closing prayer.

Session 5

1. Welcome the group.

2. Start with an opening prayer.

3. Ask the group what insights/breakthroughs/testimonials they encountered as a result of what Holy Spirit has been showing them.

Suggested Discussion Starters:

a. In the past, how were your attempts to quit sugar or release weight perfection-driven?

b. What is your self-perception? Do you believe that you are truly an overcomer?

c. What thoughts come to mind when you think about living a sugar-free lifestyle?

d. What are your trigger foods? What are your boundaries around them?

4. Make a closing remark or statement to tie in the entire conversation.

5. Have the group read the post-challenge lessons for next week's session.

6. End with a closing prayer.

Session 6

Think about how you will make the final session memorable.

Maybe end with a sugar-free recipe share or something celebratory or give out little rewards to the group's commitment.

1. Welcome the group.

2. Start with an opening prayer.

3. Ask the group what insights/breakthroughs/testimonials they encountered as a result of what Holy Spirit has been showing them.

Suggested Discussion Starters:

 a. How do you put yourself in compromising situations that make it difficult to maintain your boundaries? What will you do differently next time?

 b. How has Holy Spirit been speaking to you? What are your biggest takeaways from this experience?

 c. What foods will you reintroduce into your healthy eating plan?

4. Wrap up the session with closing words/thoughts. Encourage the group to continue the great work that they've begun.

5. End the session with a closing prayer.

Thank you again for taking the time to lead your group. You are making a difference in the lives of others and having an impact on the Kingdom of God.

Other *Weight Loss, God's Way* Offerings

Weight Loss, God's Way equips women to rely on God as their strength so they can live in freedom, joy, and peace. At the end of the day, that's what we really want. Let's be honest, if you never achieved that mythical, elusive number on the scale, but were fully able to live a life of freedom, joy, and peace, would that be enough? I know for me the answer is a resounding 'YES!!!'

We provide a multidimensional approach to releasing weight. It encompasses the whole person—spiritual, psychological, mental, nutritional, physical, and even hormonal! We believe that you must address the whole person — body, soul, and spirit. If you're looking for a program that just tells you what to eat and what exercises to do, this ain't it.

This program has helped thousands of women break free from all the roadblocks that have been hindering their weight loss success while discovering their identity in Christ.

The Weight Loss, God's Way Program offers a variety of free and paid courses and programs.

They include the following:

A YouVersion Bible Study

A free basic introduction to Step 1 of the Weight Loss, God's Way program. To learn more, go to:

https://www.bible.com/reading-plans/20974-weight-loss-gods-way-cathy-morenzie

Or from the YouVersion Bible App, click the bottom center, 'check-mark' button to open devotions, and search for 'Healthy by Design to find our free devotionals:

The Weight Loss, God's Way Newsletter

Join the free Weight Loss, God's Way community and receive weekly posts designed to help you align your weight loss with God's Word. You'll also receive our 3-Steps to Overcome Emotional Eating guide free. To join the newsletter, sign up at:

cathymorenzie.com

The Membership Program

A done-for-you, step-by-step guide to the entire program. We lead our members through a different weight loss devotional every month tackling subjects from emotional eating, prayer, self-esteem to workouts and (of course) healthy eating. Dozens of bonus tools like group coaching calls, forums, and accountability groups. To become a Weight Loss, God's Way member, go to:

christianweightlossgodsway.com

Bible Studies for Churches and Small Groups

The membership program can also be experienced a la carte with a group of your friends or with your church. Take one of our three—to-six-week studies on a variety of health and weight-releasing topics. To learn more about starting a Bible study in your home or church, go to:

https://www.cathymorenzie.com/start-a-wlgw-group/

Books and Devotionals

You can find all of our Healthy by Design series of weight loss books here:

christianweightlossbooks.com

Keynote Speaking

Want me to visit your hometown? Need a speaker for your annual conference or special event? My fun and practical approach to Weight Loss, God's Way will give your group clarity and focus to move toward their weight loss goals. To learn more or to book a speaking engagement, visit:

https://www.cathymorenzie.com/speaking/

Private Coaching

Prefer a more one-on-one approach? I have a few dedicated time slots available to coach you individually to help you fast-track your results. To learn more, go to:

https://www.cathymorenzie.com/coach

About The Author

Cathy Morenzie is CEO of and operates a ministry-minded health and weight- releasing company that has blessed hundreds of thousands of women around the world. She has been a voice to the faith-based health movement for over 35 years. She resides in Ontario, Canada with her husband Preston.

Cathy is a highly sought-after international speaker and coach. She has given away 1 million free teachings through YouVersion devotionals and daily messages on YouTube. When she's not writing and teaching, Cathy and her husband enjoy hiking and traveling.

Learn more at www.cathymorenzie.com.

Follow Cathy at:

https://www.facebook.com/weightlossgodsway/

https://www.youtube.com/user/activeimage1

https://www.pinterest.ca/cathymorenzie/

https://www.instagram.com/cathy.morenzie

Made in the USA
Monee, IL
17 December 2023